Saint Joseph Catholic Church: A Living History

Indigo Custom Publishing

Publisher	Henry S. Beers
Associate Publisher	Richard J. Hutto
Executive Vice President	Robert G. Aldrich
Operations Manager	Gary G. Pulliam
Editor-in-Chief	Joni Woolf
Art Director/Designer	Julianne Gleaton
Designer	Daniel Emerson
Director of Marketing and Public Relations	Mary D. Robinson

Printed in China

Library of Congress Control Number: 2006935987

ISBN: 0-9776711-6-X
ISBN (13 Digit): 978-0-9776711-6-8

This book is edited to the *Chicago Manual of Style*. Any deviation from accepted style issues is made in deference to Catholic traditions, the name change in 2004 from St. Joseph's Catholic Church to St. Joseph Catholic Church, and the wishes of the Diocese of Savannah.

Indigo custom books are available at quantity discounts with bulk purchase for educational, business, or sales promotional use. For information, please write to: Indigo Custom Publishing, 435 Second Street, SunTrust Bank Building, Suite 320, Macon, GA 31201, or call 866-311-9578. www.indigopublishing.us

DEDICATED TO THE FOUNDING FAMILIES
WHOSE DEVOTION AND SACRIFICE
MADE POSSIBLE ST. JOSEPH CATHOLIC
CHURCH, AND WHO, BY THE CHOICES
THEY MADE, LEFT AN ENDURING LEGACY
FOR CATHOLICS IN MACON AND
CENTRAL GEORGIA.

DEDICATED ALSO TO THOSE OF THIS
GENERATION WHO COMMITTED
THEMSELVES TO THE LABOR OF LOVE
AND WHOSE SACRIFICIAL GIVING
ENSURED THE GLORIOUS RENOVATION
THAT PRESERVES ST. JOSEPH CATHOLIC
CHURCH FOR FUTURE GENERATIONS.

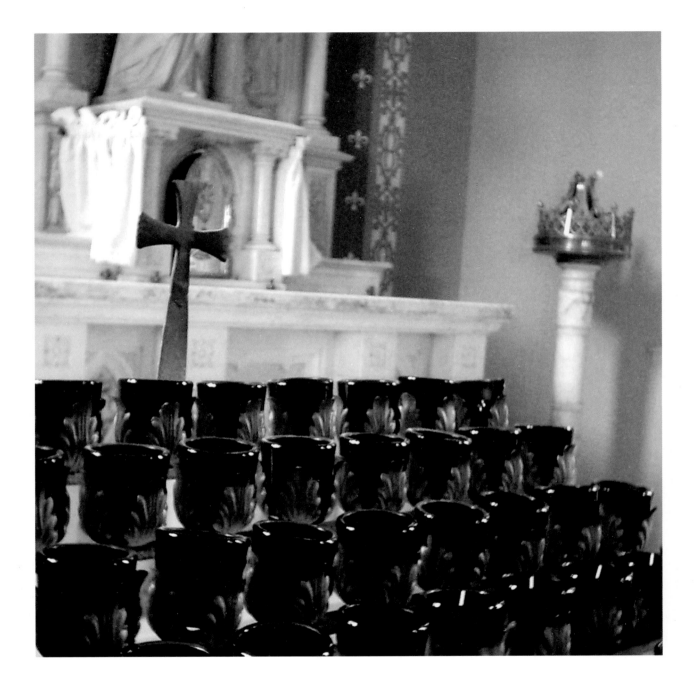

TABLE OF CONTENTS

DEDICATION 3

FOREWORD
Father Allan J. McDonald, Pastor 6

ACKNOWLEDGMENTS 8

LETTER FROM THE BISHOP OF SAVANNAH 9

HISTORY OF EARLY CATHOLICS IN MACON 11
AND BUILDING OF THE CHURCH
Joni Woolf

THE RENOVATION OF ST. JOSEPH CHURCH 37
Chris R. Sheridan Jr.

PAINTING AND DECORATIVE FINISHES 72
Tony Long

STAINED GLASS: THE WINDOWS OF ST. JOSEPH CHURCH 87
Joni Woolf

THE STATIONS OF THE CROSS 143
Katherine T. Brown, Ph.D

STATUARY 162
Katherine Hutto and Joni Woolf

OBSERVATIONS AND REFLECTIONS 179
Chris R. Sheridan Jr.

Appendix A: ST. JOSEPH CATHOLIC CHURCH PASTORS 184

Appendix B: ST. JOSEPH CATHOLIC CHURCH ORGANISTS 184

Appendix C: STAINED GLASS WINDOWS 185

Appendix D: FOUNDING FAMILIES 187

INDEX 190

FOREWORD

Like Jacob's ladder, St. Joseph Catholic Church has been the means for generations of Catholics, both immigrant and native, to make their earthly pilgrimage a climb to the heavenly city, the New Jerusalem. It is in the confines of this majestic building, with steps and spires pointing heavenward, that people from all walks of life have been initiated into God's unconditional love and gifted with His Holy Spirit. It is here that they have tasted and seen the "goodness of the Lord" and heard His call to follow Him. It is here, after stumbling upon the rocky path of this earthly pilgrimage, that they have been graced with true repentance, heard the words of forgiveness, and experienced healing and reconciliation.

A second birth through Holy Baptism into the Body of Christ for infants born into Catholic families and for adult converts who have responded to the Lord's invitation to be born again into His Church is integral to the parish's life and ministry. Lives well lived have been commended to God's eternal embrace and broken lives have experienced the prayer and support of this parish community. Prayers for the living and dead have been offered. Like incense rising to heaven, so too these prayers have risen as a pleasing fragrance to the God who hears and answers them according to His will.

In this building of bricks, mortar, glass, and artistic genius, something more is at work than the lavish display of ornate beauty and the skills of those who made this edifice into a landmark and a magnet for tourists. God's presence is in this holy place and in this holy place the human and the divine intersect in a mystical communion of love and life.

The Church's edifice is itself a statement, not only about the loving grandeur of God but also of the aspirations of the people who built it. Their vision became an architectural statement about themselves, their Catholic faith, and the foundation upon which their lives would be built and formed. Clearly the most dramatic landmark in downtown Macon, St. Joseph Church stands as a testimony to the sacrifice of time, talent, and treasure that these people of faith were willing to give "to the greater glory of God" and in the development of their faith, hope, and love.

In recent years and in the same vision and spirit of the generous, loving stewardship of their forebears, St. Joseph Church has undergone a much needed renovation. Reflecting the living and changing reality of the people who enter this temple, the Church structure has undergone significant interior

changes over the decades since it was consecrated in 1903. Today's remodeled sanctuary serves the liturgy of the Church that has evolved since the Second Vatican Council. The new altar is the focal point of the worship of God and the instrument of His grace that makes the lives of His people a "living edifice" of God's abiding presence and holiness in the world.

St. Joseph Church building is also a powerful symbol of the mission of the Church in Macon, Georgia. The mission of the Church is to continue the ministry of the Risen Lord Jesus who remains with us in the Holy Spirit. Jesus is still heard when the Word of God is proclaimed in the Church's worship. His divine presence is encountered wherever two or three gather in His name. His ministry of reconciliation and redemption continues through the celebration of all seven sacraments of the Church, especially the Most Holy Eucharist. Nourished and sustained by the Church's liturgy and sacraments, Catholics are called to be Christ-like at home, work, and recreation, as well as to have a significant influence in the secular and political world.

Begun by the Jesuit priests of another era, the priestly ministry of this parish has been handed over to capable diocesan priests. The Sisters of Mercy who began and staffed St. Joseph's School and Mount de Sales Academy have been succeeded by capable lay leaders who understand and embody the Second Vatican Council's teaching that all Catholics, clergy and laity alike, are called to holiness and to the Church's ministry of living and handing on of the Faith. The laity, also, is involved in full time and part time ministries of the Church as well as a whole host of volunteer ministries. St. Joseph parishioners, inspired by the architectural beauty of their Church building, have understood over the generations the need to assist the poor and marginalized in a variety of concrete ways.

"Taste and see the goodness of the Lord," as you make your pilgrimage through the stories told in words and pictures of this book. Those who worship at St. Joseph Church and those who visit this "jewel of the South" experience in an intimately significant way the God who created us and the God who calls us to be in communion with Him. Just as this Church reflects the glory of God, so too may the lives of those who pass through this monument of faith, hope, and love reflect lives "To the Greater Glory of God!"

Father Allan J. McDonald, Pastor

ACKNOWLEDGEMENTS

Heartfelt gratitude is expressed to all those who, in ways large and small, have contributed to the creation of this pictorial history of St. Joseph Catholic Church. Thanks are expressed especially to those who have written previous histories, and whose writing and research were the basis of much that is in this book. Especially, we acknowledge Sister Mary Sheridan, R.S.M., whose 2001 *History of Saint Joseph's Parish Macon* has been one of the main sources. We also gratefully acknowledge Robert H. Wright, whose 1991 *A Brief History of St. Joseph's Parish and the Catholic Church in Macon* provided important information and insights into the history of the parish. *A Walk through St. Joseph's Catholic Church*, written by Msgr. John Cuddy in 1995, was most helpful in preparing captions for the stained glass windows.

Saint Joseph Catholic Church: A Living History is a study in photographic excellence, thanks in large part to the talents and commitment of photographer Maryann Bates, who not only took most of the photographs that appear here, but also worked as an artist, helping with the painting and renovation of decorative items. Other photographers whose work has added dramatically to the project are Craig Burkhalter, Walter Elliott, Glenn Grossman, Mark Strozier, and David Sutton. Artists Katy Olmsted, Renate Rohn, and Ray Snyder helped turn vision into reality with their artistic gifts.

Thanks go to Rolf Rohn, Liturgical Artist & Designer, Rohn Design Group of Pittsburgh, Pennsylvania, who guided the re-decorating team, designed the lighting and liturgical furnishings, and oversaw the stained glass restoration.

Thanks go also to Father Allan McDonald, Gillian Brown (diocesan archivist), Katey Brown, Ph.D, Donna Bushey, Chris Edwards, Muriel Jackson, Frank McKenney, Tony Long, Chris R. Sheridan, Christopher Stokes, and the staff at Indigo Publishing for their help in research, writing, and proofing the book in various stages. Much gratitude is expressed to Indigo publisher Henry Beers, who, as a member of this parish, gave generously of his time and expertise to make this a superior publication, one of which the parish can be proud for many years to come.

To all the members of St. Joseph Catholic Church, as well as the rectory staff, who provided information, anecdotes, and photographs, a very special thanks is offered. The book would not be as rich without your wise and loving remembrances.

Much gratitude and thanksgiving go to Katherine Hutto, who spear-headed the project from the beginning, keeping the publisher and all others involved on task, while researching historical information from a variety of sources, always seeking accuracy and verification of all materials that became a part of the document. Her dedication to perfection is legendary, and the proof of it appears in these pages.

To all those known and unknown, who have made this book a reality, the thanks are unending.

Dear Friends,

Fifty years ago, the State of Georgia was divided into two dioceses. How fortunate that the City of Macon and Bibb County remained part of the Diocese of Savannah. The history of Catholicism in middle Georgia, its growth, nourishment and development, is dramatically symbolized not only by the beautiful church of St. Joseph's, but by the people of Macon, Bibb County, and the surrounding area. You can be proud of who you are and of the heritage that is yours. It is something that has been passed on by preceding generations of stalwart Catholics.

I had the privilege of blessing the new altar of St. Joseph's Church on July 1, 2006. That blessing was the culmination of the renovation and restoration of St. Joseph's. The refurbishment and enhancements have added a breathtaking ambience that defies description. It suffices to say: "a thing of beauty is a joy forever."

As I indicated in my homily on July 1, 2006, God's majesty is not added to by the beauty of this place but our need to express the grandeur of God's creation is realized in this sacred space.

The publication of this exquisite volume is an expression of gratitude for past generations who built this temple; it is an expression of love for present generations who maintain this structure, and an expression of hope for future generations who will in faith preserve this heritage.

This edifice was built for the greater glory of God – *Ad Majorem Dei Gloriam* – the motto of the Jesuit community. Their vision made possible this icon of God's presence.

Walk always in the light of God's love.

+ J. Kevin Boland

Most Reverend J. Kevin Boland
Bishop of Savannah

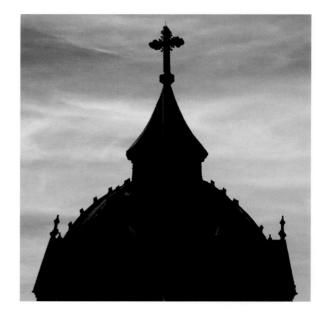

HISTORY OF EARLY CATHOLICS IN MACON AND BUILDING OF THE CHURCH

Joni Woolf

The history of our institutions is preserved in recorded history—those things written down in books or ledgers that tell of beginnings, major events, tenures, and growth. Then there are the apocryphal stories—the legends, the oral histories passed down from generation to generation, telling the stories in ways that transcend facts and figures. These stories often tell a greater truth, revealing the heart and soul of the institution in ways that a ledger—or data on a compact disc—simply cannot do.

Such is the unfolding story of the history of St. Joseph Catholic Church. The earliest references to Christianity and Catholicism in Macon concern stories handed down through several centuries about two American Indian boys (or one, depending on who tells the story) who were baptized by the priests accompanying Hernando DeSoto when he explored Middle Georgia in 1540. The Ocmulgee River was nearby, and it is believed that the first Christian baptisms in North America occurred then and there. The banks of the Ocmulgee River were a fitting place for the beginning of the story of Catholics in Macon—a story that is being written every day by the thousands of members of St. Joseph's whose lives bear witness to greater realities than mere facts.

Catholics were active in Macon from the time of the city's founding in 1823. The parish now known as St. Joseph Catholic Church had its recorded beginning in 1841, when Father James Graham was sent to Macon as pastor to the Macon Catholic community. He purchased from Elam Alexander, prominent Macon architect and contractor, an old Presbyterian Church building for one thousand dollars. Alexander is quoted as saying, "I was the contractor that built the first Presbyterian Church in Macon; ten years

Though some accounts of the first Catholic Church indicate a Fifth Street location, significant recent research indicates that this first Catholic Church, called Church of the Assumption, was on the corner of Fourth and Poplar streets. By the time the Civil War ended, the parish had outgrown the Church building and the property was sold and dismantled. (After the building was disassembled, it was rebuilt for a second Baptist Church at Hawthorne and Third Streets; it still stands in 2006 at that location, serving the congregation of Fulton Baptist Church.)

A second Church, also built by the Presbyterians, was purchased in 1866 for a price of six thousand dollars; another ten thousand was spent in making improvements. From its original fifty members, the congregation grew to eight hundred members. Located on Fourth Street—what is now Broadway—between Mulberry and Walnut streets, this building was used until 1892. According to Robert H. Wright's 1991 *A Brief History of St. Joseph's Parish and the Catholic Church in Macon*, it is not known exactly when the parish changed its name from the Church of the Assumption to St. Joseph's Church. We know the 1866 *Macon City Directory* lists St.

The first Catholic Church in Macon, Church of the Assumption, was bought from the Presbyterians. Moved from its original location at the corner of Fourth near Poplar Street to the corner of Hawthorne and Third streets, it is now home to Fulton Baptist Church.

afterward, I was married in that church, and a year or two later when they built a new church and sold their first one, I became the purchaser, and two years after this, I sold it, with one acre of land on which it stood for $1,000 to the Catholics, and it became their first church in this city."

St. Joseph's School, with beginnings dating back to 1866, was known as the Fourth Street School, and in 1872 it operated as the first unit of the public school system of Macon under the direction of the Sisters of Mercy. This photo is of the current façade which was renovated in 2004.

Joseph's Church as does John C. Butler's 1879 *Historical Record of Macon and Central Georgia*.

In 1872, a remarkable cooperation between the newly created Board of Education and the Sisters of Mercy helped make public education accessible to the children of Bibb County. An arrangement with the school board enabled the Sisters to teach religion either before or after regular class hours. The Fourth Street School operated as part of the public school system until 1902. But waves of bigotry were rising throughout the state, and the Sisters were withdrawn before

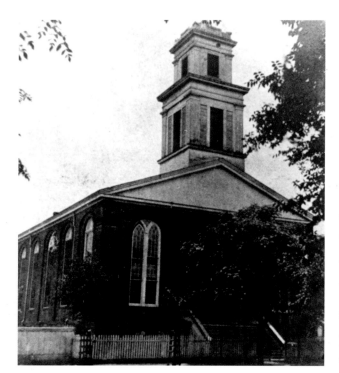

The second Catholic Church, now called St. Joseph's, was located on Fourth Street (now Broadway) between Mulberry and Walnut streets.

was founded by the Sisters of Mercy in 1876.

As St. Joseph's growth continued, it became clear that a new building would be needed to accommodate parish expansion. The city was moving up the hill, and St. Joseph's moved with it, to the city center, at Poplar and New streets. Under the leadership of Father John Quinlan, S.J., construction began on the structure at the top of Poplar Street with groundbreaking in 1889. The original design by Macon architect David B. Woodruff proved to be too expensive, so a Jesuit brother, Cornelius Otten, S.J., a Dutchman and a master builder, was called in to assist with the plans and building. He then turned for assistance to renowned Victorian architect Nicholas Joseph Clayton, who prepared drawings in 1889 that provided alternative proposals for both Romanesque and Italian Gothic Revival design elements. Clayton, of Galveston, Texas, had put the dreams of a lifetime into the construction of the great Sacred Heart Church in Galveston. That church was tragically destroyed by a tidal wave when the horrific hurricane of 1900 devastated the city. With Clayton's permission, these plans were re-worked, with many details and improvements added by Brother Otten,

any hostilities were aggravated, a move the board neither sought nor wanted. The Sisters were then assigned to St. Joseph's own school for the next September (1903). In 1874 Pio Nono College (which became St. Stanislaus College and subsequently was destroyed by fire) was established by the Jesuits, and Mount de Sales Academy

S.J., who became the supervising architect. His vast experience in building Gothic churches in Europe and America aided him in making St. Joseph's his masterpiece. Many of the artistic trimmings and the artificial stonework were of his own special design and manufacture.

Years later, on January 27, 1918, *The Macon News*, in covering the arrival of the new altars, would note that, over time, Brother Otten, S.J., was ably assisted by another Jesuit, Brother John Wagner, S.J., who "will be remembered as the 'Human Fly,' as he climbed about amid ropes and scantlings, and hung at dizzy heights at the top of the spires, which he completed."

So work began on the magnificent Gothic Revival structure, and by 1892 the Romanesque basement was completed and blessed by Bishop Thomas Becker. The congregation met for the last time in May 1892 in the old edifice at the corner of Fourth and Walnut streets, amid feelings of sadness and joy. According to a newspaper account for May 30, 1892, "Sadness to the old members of the congregation who for a quarter of a century have regularly worshiped in the old building...Twenty-five years of human happiness and sorrow, with its many joyful

wedding parties, happy christenings and sorrowful funerals, has the old church known." Still, they were excited that Mass would be celebrated the next Sunday, June 5, in the new Church.

As it turned out, this basement space was used for worship for the next eleven years. For eight of those years, construction came to a halt, due

Brother Cornelius Otten, S.J., master builder, was the supervising architect of the Poplar Street St. Joseph's Church, according to Drexel Turner's unpublished catalog of Nicholas Clayton's works.

to limited financial resources, but the Church remained active. In May 1894, St. Joseph's purchased grounds for a Catholic cemetery from the Mayor and City Council (this section is part of the historic Rose Hill Cemetery today). What was then the entrance of the Church on the New Street side can be seen today in the doors within the marble arch, beneath the long transept (crossing) windows of the upper structure.

Construction on the superstructure of the Church began on the feast day of St. Joseph, March 19, 1900. Finally, after fourteen years of construction and many sacrifices by parishioners and priests, the architectural masterpiece was completed. A glorious dedication ceremony of the upper Church on November 15, 1903, included six bishops and the faculty of St. Stanislaus College in attendance at a Pontifical High Mass. One of the highlights of the event was the musical program under the direction of Professor J. G. Weisz, organist at the church for sixty years. (Following his tenure, his daughter, Celia Weisz Giglio, was the organist for several years.) A story about the event that appeared in the *Macon Telegraph* began with these words: "If architecture may be fittingly described as frozen

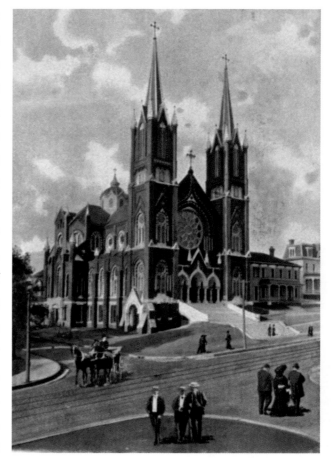

The magnificent Church is approached by twenty-six steps made of Georgia marble.

music, St. Joseph's Church, to be dedicated today, is a symphony." The newspaper article went on to say, "The church at the corner of Poplar and New streets stands as a monument to the zeal of

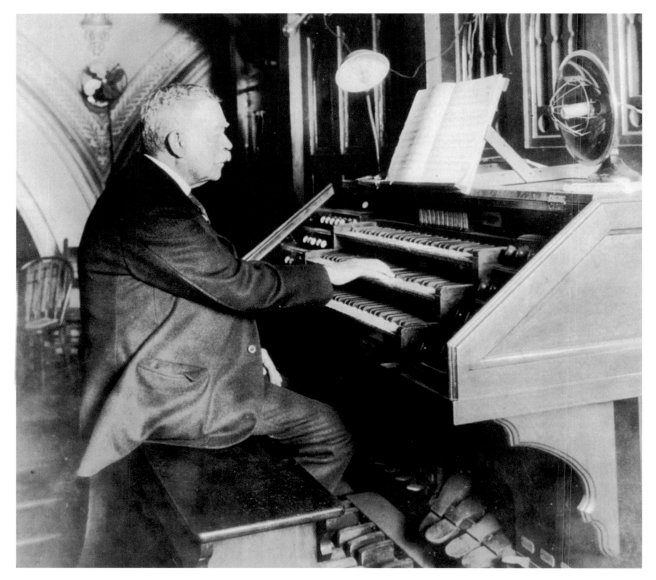

Professor J. G. Weisz, organist at St. Joseph's for sixty years, was honored in a special tribute by the Church in 1940, commemorating his diamond jubilee as organist.

the relatively small church group who erected it."

As the Church has evolved over the subsequent century, St. Joseph's is, indeed, a symphony, played over time to a huge Macon audience, both parishioners and general citizenry. The unsurpassed beauty of the architecture within a city of beautiful churches draws pilgrims and prophets into an encounter with the Holy. Because of its historical significance, St. Joseph's was listed on the National Register of Historic Places (U.S. Department of the Interior) on July 14, 1971.

St. Joseph's exterior is comprised of pressed brick and cast concrete in several shapes and sizes. The edifice is approached by twenty-six Georgia marble steps; the main entrance features three marble Gothic (lancet, or pointed) arches. On each side of the entrance are bell towers that measure one hundred-sixty-five feet in height from the foundation to the top of the crosses. Three large bronze bells were installed in 1903, and were rung manually until 1957, when automatic clock controls were installed. Called the Jesus, Mary, and Joseph bells, they ring for the daily Angelus, Sunday Masses, feast days, hourly from 8 a.m. to 8 p.m., and at the conclusion of weddings and funerals.

The spires, towering over the north end of Poplar Street, consist of four main levels; the bottom two levels contain stained glass windows on three sides. The third level contains a small window as the center arch in a three-arch arrangement, and the top level features a large louver on each side for the bells. The first and second levels add narrow lancet windows with a circular window above, forming a unified appearance. There is a front gable consisting of molded brick with a pair of ogee (bulbous-shaped with a point, like an onion) arches made from cast concrete and brick around the concrete rose window frame. On top of the gable is a cross and below the ogee curves are four small concrete columns. The crosses on top of the spires are cast iron frames with sheet metal ornamentation.

The main entrance to the Church features three marble Gothic arches resting on eight spiral marble columns of simple design. Three sets of double oaken doors lead into the vestibule (narthex). Over each door is a transom of clear beveled glass in a Gothic arch. Above the front entrance a stained glass rose window, typical of Gothic architecture, measuring twenty-two feet in diameter, dominates the space, proclaiming A.M.D.G. –*Ad Majorem Dei Gloriam* (To the

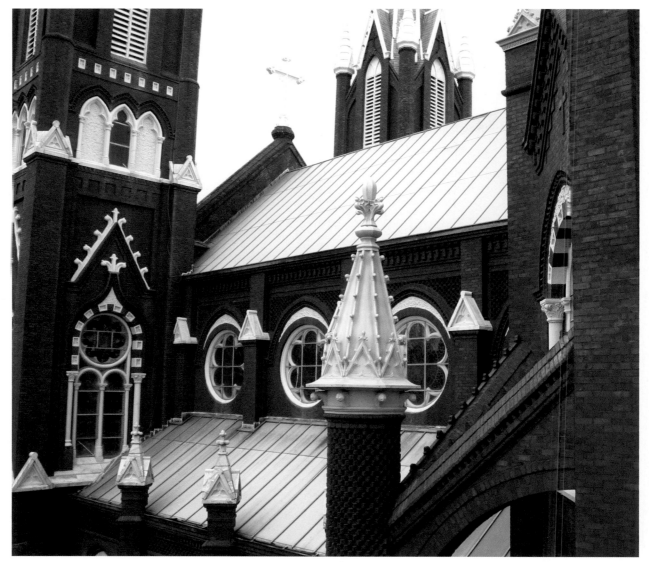

Round columns with bricks laid in a sawtooth design are among the many significant architectural elements in the design of St. Joseph Church. Such skillful techniques are an inspiration to anyone knowledgeable about brick-laying. Note the flying buttress that supports the vault.

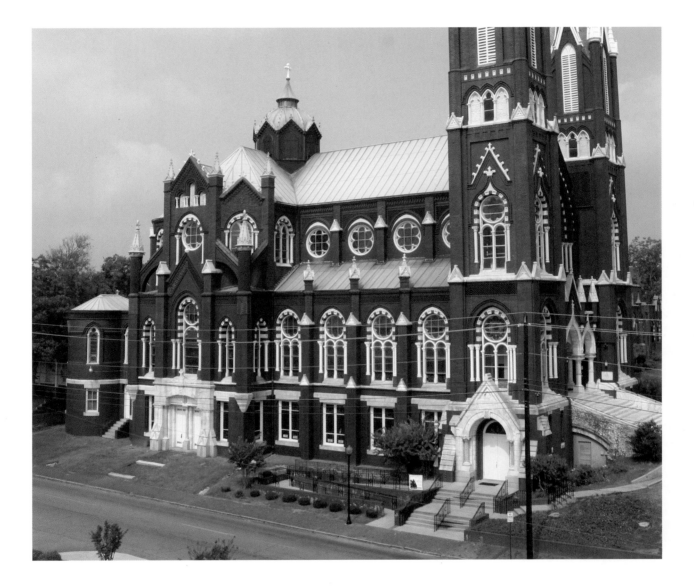

This spectacular view of St. Joseph Church reveals many of the structure's outstanding architectural features.

greater glory of God). Above the window are two opposing ogee curves of brick and cast concrete pieces, leading to the center cross above.

Viewed from the northwest or southeast, the superstructure is dominated by four pairs of brick flying buttresses (brick supports that project from the building) over the corners of the transept. There are four round brick columns laid in a sawtooth design (with corners of rectangular bricks projecting in triangular shapes, like a sawtooth) where the buttresses come together—an inspiration to anyone knowledgeable about brick-laying. The flying buttresses support the vault. The transept (crossing) is formed by three gabled ends. Each gable is topped with cast concrete pieces forming a "crocket," a Gothic ornament resembling a half-open leaf used on the edge of a gable or spire. The crockets on the spires have been removed over time. A prominent Byzantine feature is the cupola or dome over the crossing, measuring eighty-seven feet from the top to the main floor of the Church. The original cupola caught fire in 1951 and was replaced with a new one that duplicated the original. The new dome is made of concrete; viewed from the top, some of the charred wood around the floor of the interior cupola walkway is still visible.

Before the Second Vatican Council, convened in the 1960s, there was a curtained confessional on each side of the rear of the Church. Each opened on both sides to accommodate a total of four lines of penitents. The children from St. Joseph's School walked down to the Church each month for Confession. On Saturday evenings during Advent and Lent, the lines were long. After Vatican II, the confessionals were removed and a Reconciliation Room was designed into the former Baptistry. The baptismal font was moved to the front of the Church.

The interior of the Church features a cruciform-

The Last Supper is one of the windows at the Main Entrance, and was given by H. Horne, in memory of his parents.

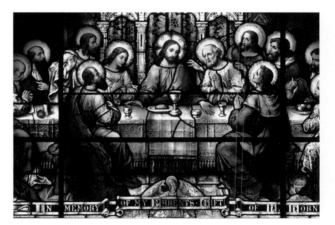

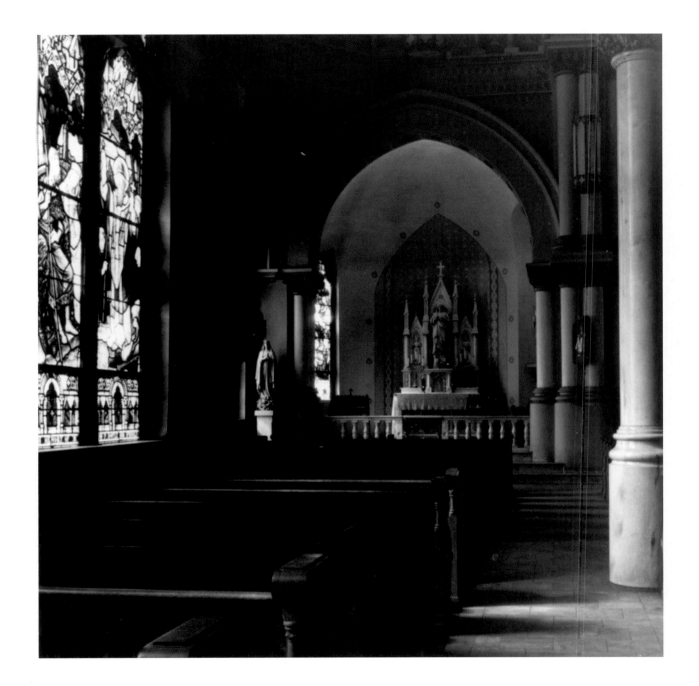

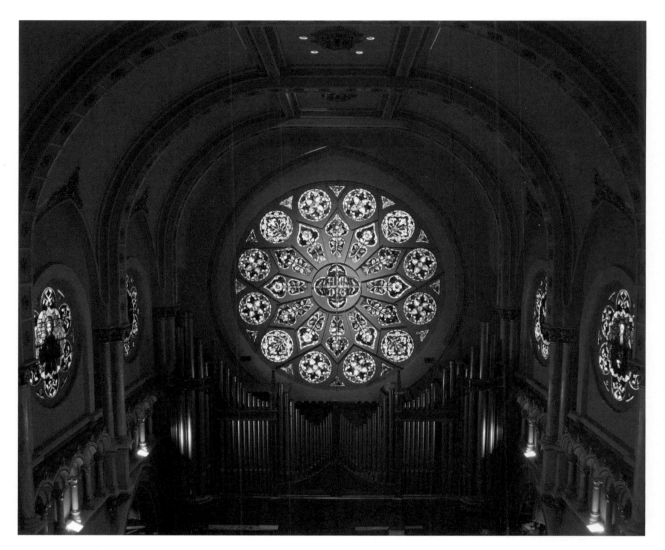

This dramatic photograph features the spectacular rose window, framed by pipes from the Schlicker Organ that was dedicated in 1986. A Romanesque feature of the interior is the barrel-vaulted (round-shaped) ceiling. The stained glass is set in a twenty-seven foot diameter concrete frame. The concrete was cast in pieces on the ground and assembled in place. In the 1950s a structural steel frame was installed to reinforce the concrete. The frame was designed by Henry Corsini, a young architect and parishioner, and installed by Chris R. Sheridan & Company.

basilica type plan with a wide nave, two side aisles, pointed arches, and an apse (semi-circular space behind the High Altar), with two flanking side chapels with sculptures. But many consider the Church's most compelling feature the High Altar, a glorious monument carved from Carrara (Italian) marble. The crucifixion scene featuring Jesus, the Blessed Mother, and St. John reminds worshipers of the substance of their faith. Mary Magdalene kneels at the foot of the Cross, and on the surface of the base of the altar is a carved representation of Leonardo DaVinci's Last Supper. Worshipers are awed by nearby marble statues of St. Joseph and St. Anne,

The mural behind this altar dedicated to the Sacred Heart and the altar on the other side of the church dedicated to the Blessed Mother were designed by Rolf Rohn and painted by his sister, Renate Rohn.

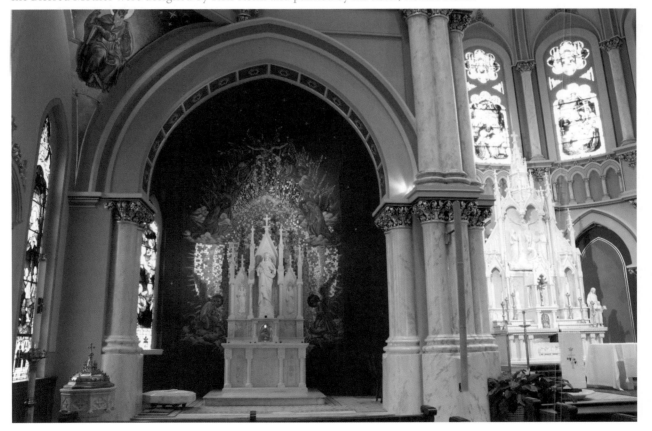

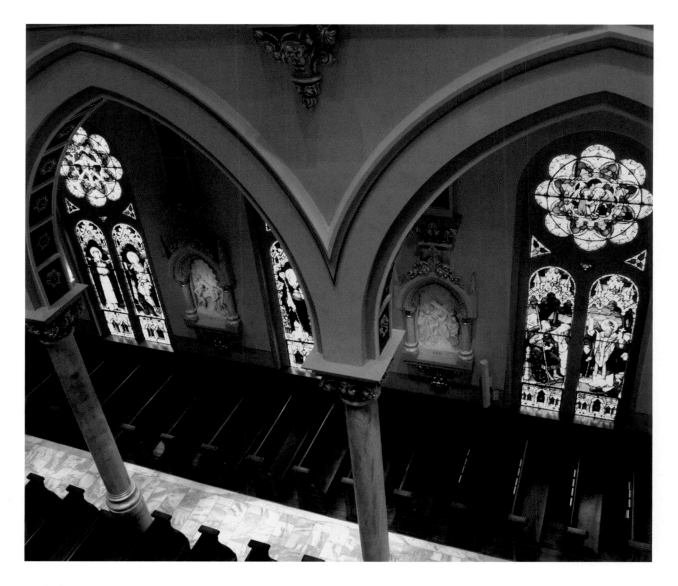

High above the nave, the photographer captures the beauty of the stained glass windows, the soaring architecture, and the simple beauty of wooden pews.

with her young daughter, Mary. On marble pillars, the archangels, Gabriel and Michael, offer homage to the scene of Christ's crucifixion.

These were not the first altars at St. Joseph's. The first altars, though beautiful, were of wood. For some years there had been a movement afoot to replace them with altars of the finest marble, from the famous quarries of Cararra, Italy, and executed by noted Italian sculptors. The glorious new altars arrived in time for the Easter celebration of 1918, and an article in *The Macon News* dated January 27, 1918, includes a description by the chief decorator of St. Joseph's Church: J.G. Degering, of the new altars and decorative scheme in great detail:

"The new main altar in St. Joseph's Church is a dream of beauty. It is in perfect harmony with the surroundings. The lace-like tracery of the central canopy surmounts an almost life-size group of the crucifixion. The simple Gothic outlines of the reredos and the high pinnacles that stand out boldly against the background are fitting ornaments of the lofty sanctuary...Beside the crucifixion group and a reproduction of Da Vinci's Last Supper, the statues of St. Joseph and St. Anne add much to purity and grace of line. They are so life-like,

and the customary stiffness of marble statuary has been totally eliminated by the artist's chisel.

"The type of architecture selected for the new altars, as well as the main part of the edifice, belongs to the Italian Gothic period of the 16th century. This pleasing example of a picturesque medieval style is totally different from what some writers have termed the 'Monastic of medieval gloom' peculiar to the different national renderings of Gothic architecture so evident in the church structures of northern and western Europe...

"Upon thorough examination, at various times during the day, of the richness of light and shadow peculiar to the elaborate art glass windows in St. Joseph's Church, we at once struck upon a plan to harmonize the colorings in such a way as to agree with the warmth and glow of the southern climate. The intensifying effect of the white marble altars calls for a neutralistic tone of rich old gold and soft restful greys in the sanctuary..."

A new altar, weighing eight thousand pounds and constructed of imported Carrara and Rosso di Levanto marble, was installed in June 2006. Bishop J. Kevin Boland dedicated the new altar on July 1, 2006, as part of the renovation. The High Altar now serves as a reredos.

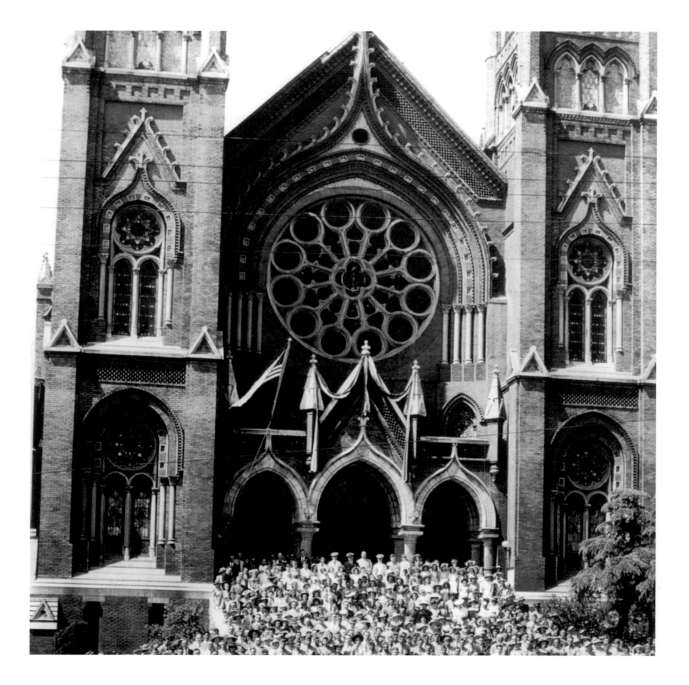

The left side chapel features an altar to the Sacred Heart. The right side chapel hosts an altar dedicated to the Blessed Mother. Their statuary is carved from Carrara marble and set before gold mosaic backgrounds and paintings. The Blessed Sacrament which is the consecrated host or "bread" from Mass which is not consumed is reserved within the tabernacle (cabinet-like structure with locked door) of the Sacred Heart altar. The Blessed Sacrament is reserved so the Holy Eucharist can be brought to the sick, dying, and shut-in and for personal and communal prayer.

The side altars are also carved from Carrara marble, while pillars of Georgia marble support the nave arcade (rows of arches supported by columns) and the floor is also Georgia marble. Along the side aisles are the Stations of the Cross, sculpted in Carrara marble and trimmed in gold leaf (see p. 143).

A Romanesque feature of the interior is the barrel-vaulted (round shaped) ceiling. By contrast, Gothic features such as pointed arches and stained glass appear in the upper story between the nave arches and the top windows. With capitals similar to Corinthian order, the smooth, rounded columns reflect the personal style of the architect.

The magnificent organ built by the Schlicker

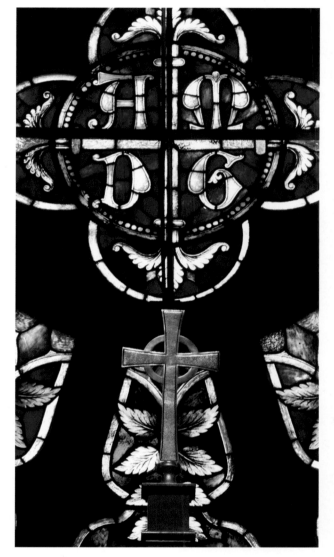

Organ Company in Buffalo, New York, was dedicated in 1986. Inside the Church, the organ can be seen by standing in the center aisle beneath

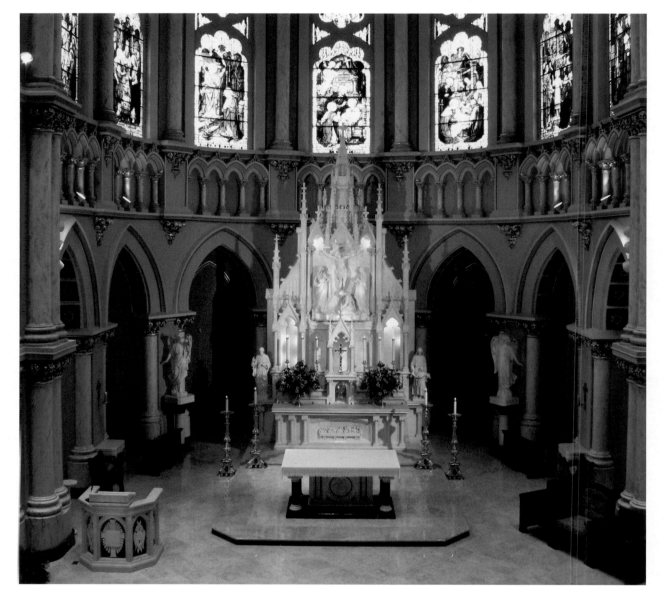

A dramatic view of the 1917 High Altar, with the 2006 altar and pulpit in the foreground.

31

the dome, and looking back toward the entrance. The rose window frames the organ in brilliant light and color. Incorporated into the organ of 1986 are parts of the original three manual instruments that were installed in 1903 by Pilcher and Sons of Louisville, Kentucky. The organ also contains some of the original Pilcher pipes and portions of the Pilcher façade and console.

Sixty-nine stained glass windows, most of which were crafted and installed by artisans of Mayer Studio of Munich, Germany, in the early 1900s, are among St. Joseph's outstanding features. All of the clerestory windows (those at the highest level inside the nave intended to flood the interior with light) are circular, enclosed by foliated design. Beneath the central clerestory window of the transept is another circular window, yet featuring an extended foliated design that fuses with a wider, elongated window below. Each of the four large windows on either side of the nave below the triforium is composed of a foliated circular head above two lancet windows. These window groups alternate with the fourteen Stations of the Cross along the interior walls. Both the foliated circle motif and the plain-shaped window design are carved into the ends of the solid oak pews in the Church.

The magnificent windows of the apse clerestory

32

The words of Jesus, "Come apart...and rest awhile," resonate at St. Joseph Catholic Church, a haven for all who seek a place of prayer and an encounter with the holy.

(those windows at the highest level above the High Altar) are effectively situated between narrow columns supporting modified arches, suggesting the simplicity of the pattern of the lancet window frequently repeated throughout the structure.

We may need to pause collectively and remember that this incredible parish Church did not spring to life overnight, with such an abundance of beautiful architectural features. There is mention that the Church was re-decorated in 1918, most likely following the fire that occurred on March 31, 1918. Re-decorating had already begun, and a protective canvas hung around the new marble altar, installed the previous December. Above the canvas, the painters' wooden scaffolding filled the Church. While the firemen were able to extinguish the fire, the fire chief said that in ten more minutes, flames would have ignited the paint-spattered canvas, mounted up to the wooden scaffolds, and created an inferno that would have destroyed the Church. Damage from this fire was limited to a six-foot square hole in the sacristy floor and a charred chifforobe, plus some smoke and water damage to the interior and the school room downstairs. The cause was said to be faulty wiring. The redecorated Church was reopened with special ceremonies on May 5, 1918. From reports, the new décor seems to have been much more colorful than previous arrangement or design.

No additional renovations took place until 1943. In 1944, the elevated marble pulpit replaced an oak one, and new lighting fixtures brought more light into the Church. The original oak pulpit had a large "clamshell" behind the speaker, directing the sound of the priest's voice out toward the congregation so that he could be heard at the back of the Church. As part of the current renovation, a new marble pulpit was installed in October 2006.

A second and more serious near-disaster for St. Joseph's Church was caused by the sparking of a neon light transformer. At an evening Lenten service on February 9, 1951, several worshipers noted a flickering light in the cupola. The fire broke out in earnest several hours after Mass was completed. By the time the firemen arrived, flames could be seen from a distance, shooting up from the top of the building. In their efforts to save the Church, the firemen brought their hoses into the building and shot a stream of water straight up into the cupola. This effort succeeded in preventing the flames from spreading, but the cupola was so damaged

that it collapsed, destroying several pews. The cross aisle in the nave dates from the time of this fire. In the early 1950s, the paint color would change again, from tan to rose. The 1951 fire most likely prompted this re-painting, the last painting that St. Joseph's Catholic Church would experience until the renovation of 2003-2006.

In 1956, the Holy Father, Pope Pius XII, divided the Diocese of Savannah-Atlanta, creating two separate dioceses—Savannah and Atlanta. Archbishop-Bishop of Savannah Gerald P. O'Hara asked that the City of Macon be allowed to remain within the Savannah diocese, and his request was granted. Soon after, Archbishop O'Hara concluded that it was time for the Jesuit priests, who had served St. Joseph's until this time, to return to their normal work of education and spiritual instruction. The first of the diocesan priests, the Right Reverend Monsignor Thomas I. Sheehan, then came to St. Joseph's Catholic Church, and a new and exciting era began. A major project undertaken during this time was the installation of a copper roof, replacing the original slate roof that was damaging the Church structure. Subsequently, there was a significant repair of all plaster and painting that did not include redecorating.

No single written history can tell the whole story. The names of many parishioners whose histories are closely identified with St. Joseph Catholic Church may not appear here. That does not, however, diminish their loyalty, their commitment, or their years of service to the parish they have loved and called home. Histories provide broad pictures of our institutions and serve as reminders of what has gone before. But much of the history of the parish is written indelibly on the hearts of its members and is there for all time.

Today, St. Joseph Catholic Church remains the focal point for Catholics in Macon; over two thousand families are registered as members. When Monsignor John Cuddy retired as pastor in 2004 after thirty-one years of faithful service, he was succeeded by the current pastor, Father Allan McDonald. The recent $2.5 million renovation effort, which included cleaning and repair of all stained glass windows, was overseen by lifelong parishioner, Chris R. Sheridan Jr. Highlights of the renovation are detailed by Sheridan in an accompanying story. Surely the parishioners and friends of St. Joseph Church who contributed to this labor of love were inspired by the devotion and commitment of the early founders, who

established the Catholic Church in Macon and were faithful overseers as it grew and prospered.

Remembering the words of St. Paul: "I planted, Apollos watered, but God gave the increase," the people of St. Joseph's know that to God alone is "the increase." The history of this remarkable parish is evidence that God has journeyed with them, loved them, and blessed them throughout the years beyond their power to comprehend.

Ad Majorem Dei Gloriam...
To the Greater Glory of God.

THE RENOVATION OF SAINT JOSEPH CHURCH

Chris R. Sheridan Jr.

My connection to St. Joseph's began four generations before I was born, when Macon's first Christopher Sheridan lent his skills as a stonemason, the natural talent of any Irishman, to the original construction of the Church. Born in Coole, County Westmeath, Ireland, December 18, 1828, Christopher Farrell Sheridan was baptized in a sod Church before emigrating to America in his teens and settling in Macon around 1859. Having stood on the site of the sod Church of his baptism, I thrill to imagine how it must have felt for him to have been a part of such a glorious undertaking as St. Joseph's. I feel a deep pride to see his name and those of his two oldest sons on the founders' plaque inside the vestibule. Of his nine children, two sons, Christopher and Robert, continued in the building industry as suppliers, and introduced my father, named for both of them, to the business of building construction.

As a very young boy, I remember my father overseeing various projects at St. Joseph's. I remember his reverence for each one, saying how lucky we are to have the forefathers we did and that we must take care of what they created. The Church was more than just a historic or religious building to us; it was a character, a part of the family. My great grandfather, Christopher, was buried from that Church. My grandparents were baptized, married, and buried from there, as was my father. My mother was buried from there and I was baptized there, along with all my children. The sense of caring for a family member was there with me throughout the process of this renovation, and I feel myself standing on mighty shoulders as I take my place in the line of those who have manifest their dedication to this Church through their work. When my father went into business, it was with his friend, Angelo Punaro; they formed the Sheridan Punaro Company. Angelo married a Benedetto, who came from a long line of caretakers of the Church, and who was my dad's cousin. The Irish and the Italians constituted a large part of the early parish, and took great care of our Church. Angelo and my dad shared a deep

heritage of care for the Church over many years. They gladly carried the load on their shoulders, and for that dedication to St. Joseph Church, the current generation of workers gives thanks. For me and for all who were lucky enough to be involved, this project was and is the work of a lifetime.

My part began simply enough. One Sunday morning in 2002, a member of the choir stopped me after Church to point out the badly bowed stained glass windows. Folks more observant than I felt the windows were going to fall out of their frames. How could I have missed seeing the damage, with all the time I'd had to look around and see what was happening (when I should have been paying attention to Mass)? Perhaps my familiarity had blinded me to her slow decline, but thank goodness others were more attentive. A small group of parishioners had seen it was time for major repairs, and they took the opportunity of the one hundredth anniversary of the Church's 1903 dedication to propose a major renovation. Our firm was asked to head up the project.

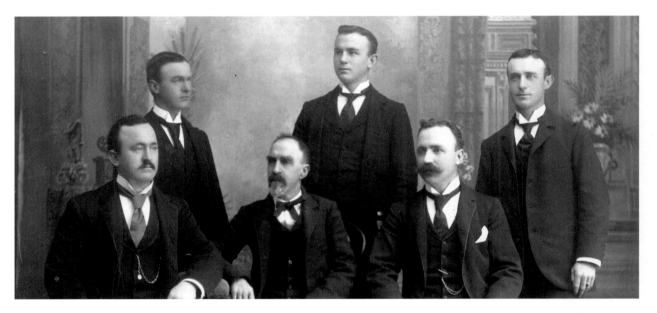

One of the founders of St. Joseph Church was Chris F. Sheridan, front row, center. At his right is his son, Thomas Sheridan, and at his left, his son Robert. Standing in the rear are his sons, Patrick, Edward and Chris F. Sheridan Jr.

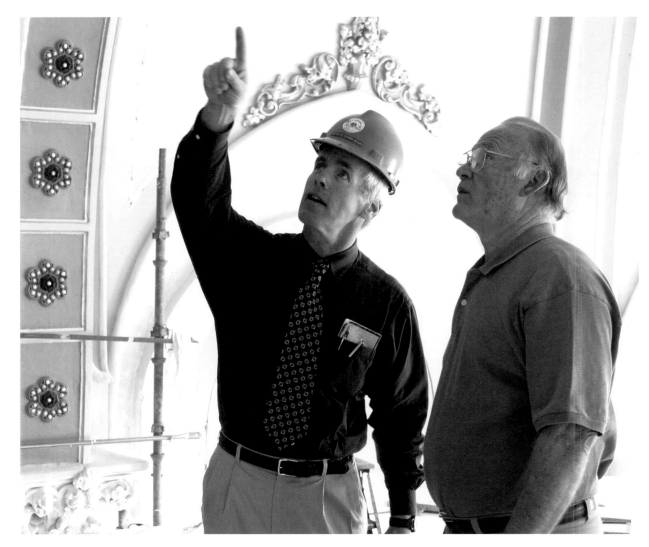

Chris Sheridan and Tony Long discuss the renovation project as it progresses. This photo was taken from a scaffold platform about forty feet above the floor. Note the medallions in the panels that are part of the high roof. Each medallion is painted with four colors plus the gold leaf. From the floor it is almost impossible to discern these colors, but from that distance they produce a subtle but very rich effect. It is this level of detail that the renovators noted in the windows and carvings and that they wanted to continue in the painting.

THE RENOVATION PROCESS

Chris R. Sheridan Jr.

Where does one begin? How do you start such a process? The parish was very blessed to have a beloved pastor, Monsignor John Cuddy, who saved enough money to begin the work and who loves the church as much or more than anyone. His desire was to "maintain it as a place of peace and prayer where those who enter it can come closer to God." So we began talking to Church decorators and lighting designers and large stained glass studios around the country. Two things became clear in that process: age had taken a greater toll than we all realized, and using the large stained glass studios and Church decorators was going to be expensive well beyond the savings of the parish. Luckily, the Cathedral of St. John the Baptist in Savannah had undergone a recent restoration and Monsignor William O. O'Neill was very gracious to an inquiring contractor who needed information specific to certain aspects of Church renovation. He recommended we hire Mr. Rolf Rohn, Liturgical Artist & Designer, Rohn Design Group in Pittsburgh, Pa.

Rolf met with a small group comprised of Patty Downs, local interior designer; Tony Long, a local commercial paint contractor who also had a family history that twined around St. Joseph's; and me. Tony and I had grown up watching our fathers maintain the Church. My dad, Chris Sheridan Sr., would contract with Mr. A. T. Long to do whatever painting was required for maintenance. The two of them dedicated themselves to figuring out the best but least expensive way to maintain the grandeur of the building. Tony and I felt a particular satisfaction in reprising those roles. We three "locals" had collaborated on several major restoration projects over the years and felt we might be able to pull this one off with a little help. We quickly came up with a first pass of a decorating scheme and made a test panel the week before Holy Week in 2003. The parish in general loved the proposed changes. Rolf began teaching us all about stained glass work, and we began interviewing local stained glass studios. Rolf stayed in my guest house when he was in town, and he and Tony and I would plan and discuss for hours at a local downtown restaurant. Over the next several months, we evaluated the needs of the building, produced a detailed set of plans, and bid and negotiated contracts

with local contractors and artisans. The scope of this project was as follows: Restore the over 4,600 square feet of Franz Mayer stained glass windows, install a new lighting system, repair all damaged plaster, redecorate the entire Church with what turned out to be the fifth decorating scheme in its history, and clean the marble of over one hundred years of grime. We were able to do all this work with local talent and save a great deal of money in the process.

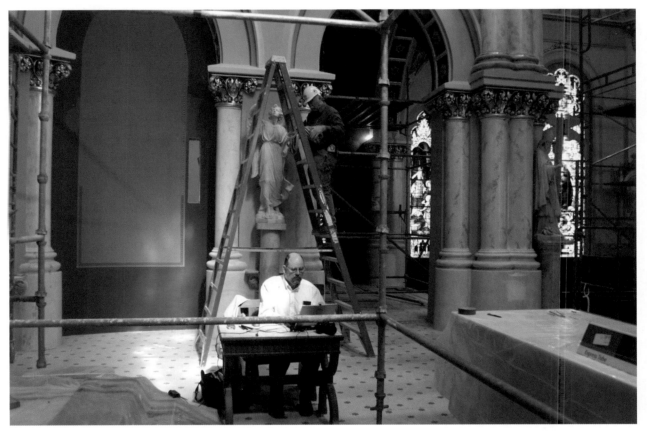

Rolf Rohn of Rohn Design Group works from a make-shift desk, set up in the apse among ladders and scaffolding. Behind him on the ladder is Dennis Tindal, Sheridan Construction Company's project superintendent. Tindal had field responsibility for the entire project, and was on the job from start to finish.

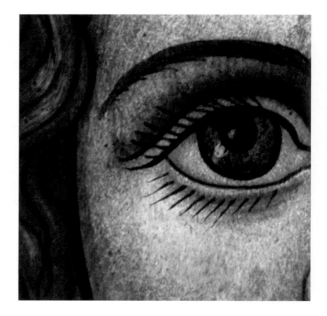

Restoring The Stained Glass

Chris R. Sheridan Jr.

There are over 4,600 square feet of stained glass in St. Joseph Catholic Church, and one can spend hours studying and enjoying it. The enduring quality is truly world class. In fact, many first time visitors gasp at the beauty of the place and then walk around speechless for several minutes.

To set the stage, consider a letter written to Maryann Bates, one of the artisans who became captivated by the project, by Wilfried Jaekel, an employee of the Franz Mayer Company of Munich, Germany, the company that produced the original glass and that is still in existence today.

"The Mayer studio started in 1847 [designing and constructing] with religious furniture such as altars, communion benches etc. as well as statuary in wood, terracotta, stone, marble and stone composition. The idea of the founder Joseph Gabriel Mayer was to unify the three applied arts, sculpture, architecture, and painting. His paradigm was the medieval site huts in which the complete decorations and embellishments of churches had been made. Stained glass was added about 1862." [They opened a sales office in New York in 1888.] "The Macon order had been attended by the New York agency which at that time was managed by Joseph B. Kelly. We may mention that at that time, Munich had a world-wide reputation for its arts, especially stained glass, and that many clients came personally to Munich to order Munich style stained glass windows."

To meet the strict budget demands of the project, Sheridan employees had to learn certain parts of art glass restoration. These craftsmen first carefully photographed and labeled each window section. Then they used small air and hand operated chisels and diamond saws to cut the window free from its concrete frame. The glass had been installed with portland cement mortar into the frame, and the removal operation was difficult and delicate. Each window was then placed in job-made plywood crates and labeled. The first windows were taken twenty-five miles up I-75 to A Touch of Glass Studios, where Celia and Jim Henigman carefully and expertly removed them from the crates. The couple made a rubbing of each panel, showing every piece and noting any damage. The windows were then photographed again prior to the restoration process.

The creation of stained glass windows is a very involved process, occurring over several stages. The process begins with the initial design plan, showing the visual elements of the window. Once the theme is established, and the appropriate imagery and subjects are chosen, an artist creates a full size drawing of the composition, known as a cartoon. From this rendering, the stained glass designer creates a second drawing of the scene that divides the composition along the lines of the lead came (strips that hold the glass in place). Care must be made to make those very prominent lines both an integral part of the scene and structurally sound to hold up the heavy glass. The base glass is then selected, chosen for desired color and texture. On our windows, notice the different shades of color in the base glass. Take a tree, for instance. The leafy part of the tree may take up several pieces of glass. Each of these groupings of glass is a slightly different shade. Not only does this color scheme add depth and richness to the glass, but if one is ever broken, then the restorer need only work within that palette as he may never be able to match exactly the glass of one hundred years ago. The artists who lived at the time of my great-grandfather had great forethought.

Once the base glass is selected, the image details are painted onto the glass. The paint is made from

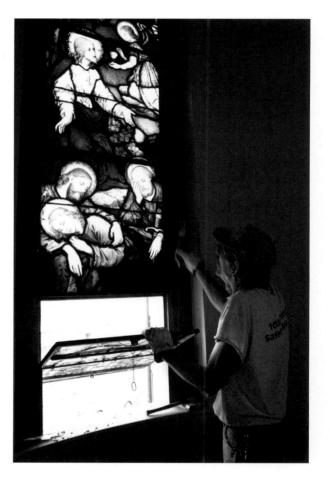

Bill Amann of Chris R. Sheridan & Company removes a panel. He personally removed and re-installed over 80 percent of the windows and did not break a single piece.

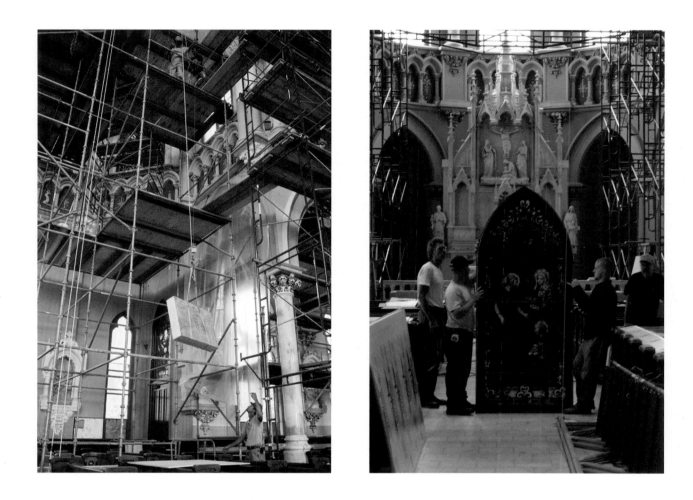

The work begins: plywood crates were made on the job and the stained glass was packed into them for shipping. Right: The scene of The Holy Family over the side door is being crated for shipment to the stained glass studio for restoration.

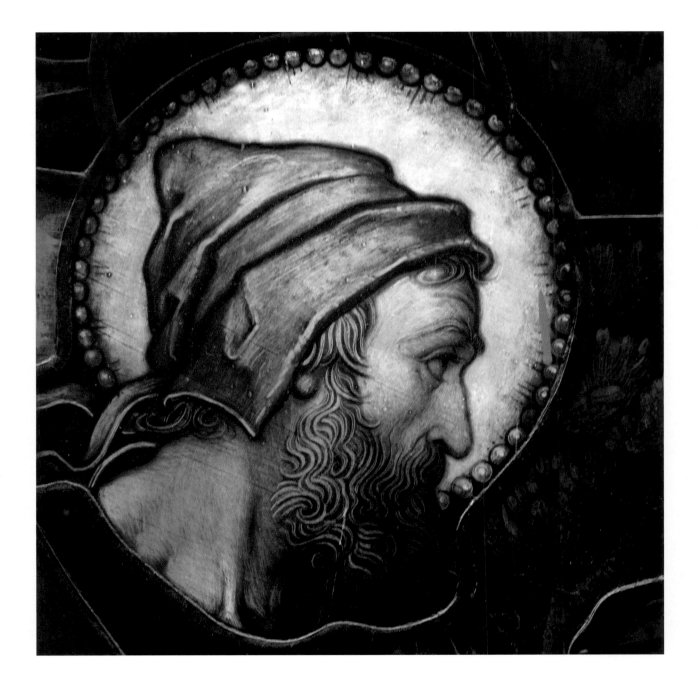

a slurry of ground-up glass, water, and gum arabic. There are two techniques for painting on glass. With the first, a thin blanket of paint is applied to the window with a large flat brush, completely covering the glass. Then, the artist scrapes away part of the paint to reveal the colored glass underneath. With the second technique, the artist uses a thinner brush with a thicker slurry of paint, and adds the details directly to the glass, exactly where he or she wants them. The painted glass is then fired in a kiln to around 1,200

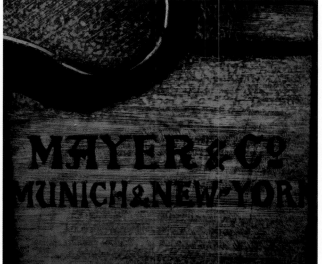

At left is detail of a bell tower window; it portrays Christ wearing a crown of thorns. Above: The camera comes in close on the Mayer Studio's insignia.

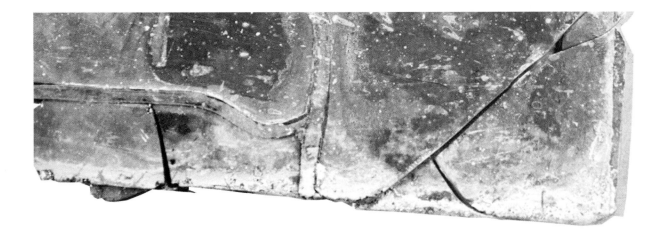

This is how much of the glass appeared before it was soaked, brushed, scrubbed, and cleaned. Many edge pieces were broken but the original designer allowed for this and they were relatively easy to replace.

degrees F. The artist will combine many layers of paint, each using combinations of different colors and densities to achieve a very intricate work. Up to four firings may be necessary to get one piece of glass the way the artist wants. Note the tremendous level of detail in even the most insignificant pieces of glass in these windows. There are also other techniques such as silver staining of the glass that were combined on these windows to achieve a high level of richness. The best artists of the time were used to paint the faces or the hands. The lesser skilled artists were used to paint the cloth and trees. Finally, the least qualified artists were used to paint the outer pieces of glass that form the landscape or architectural surroundings. If one carefully studies even these least pieces, one can marvel at the detail.

Once the rubbing and photographs have been done, the lead cames are removed and sent to the recycling center. The glass is soaked in a mild cleaning solution for about a week, softening the years of dirt, old paint, and glazing compound. It was a terrifying sight to see stacks of our wonderful

49

Each window, upon uncrating at the studio, was photographed and rubbed. All defects were noted. All original glass, the photos, and the rubbings have been saved.

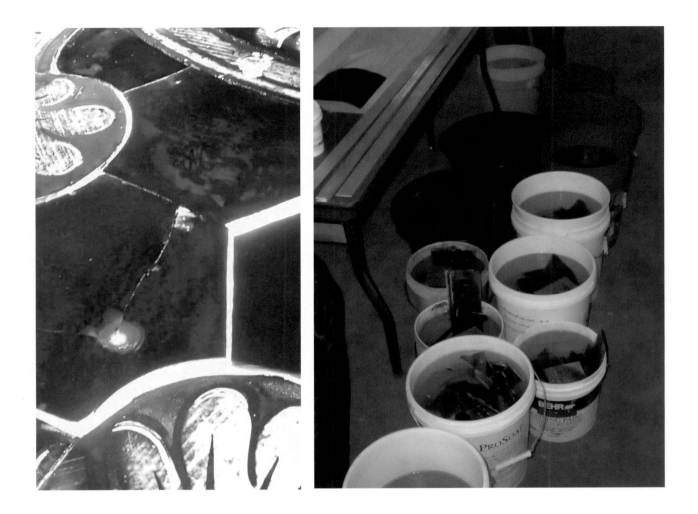

The photo on the left depicts part of the rose window, showing two of the three hundred bullet holes that were in the window. They appear to have been done with BB guns. Protection glass, installed in the 1960s, has no damage, so the holes must have been made before that time. The picture on the right could be frightening to parishioners. Each bucket contains a panel of a stained glass window. Note the duct tape in each bucket. This label was placed on the panel before the window was removed and acted as a tracking tag for that panel. It remained with the panel until the window was returned to its original location.

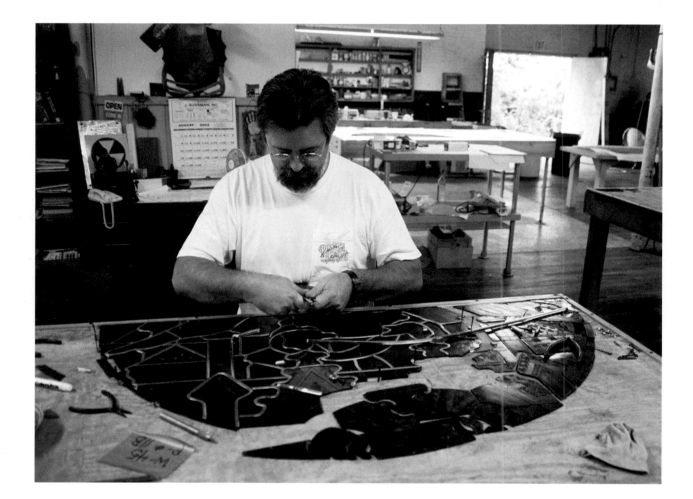

Jim Henigman lays out the glass in its original design and prepares it for leading.

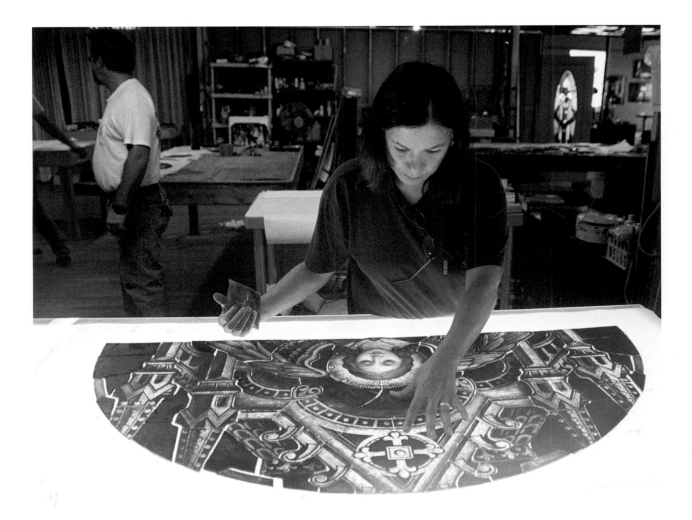

Inside the artist's studio, the tedious work of cleaning and repairing goes on for weeks, as the numerous windows are restored. Here, Celia Henigman places glass to be re-leaded.

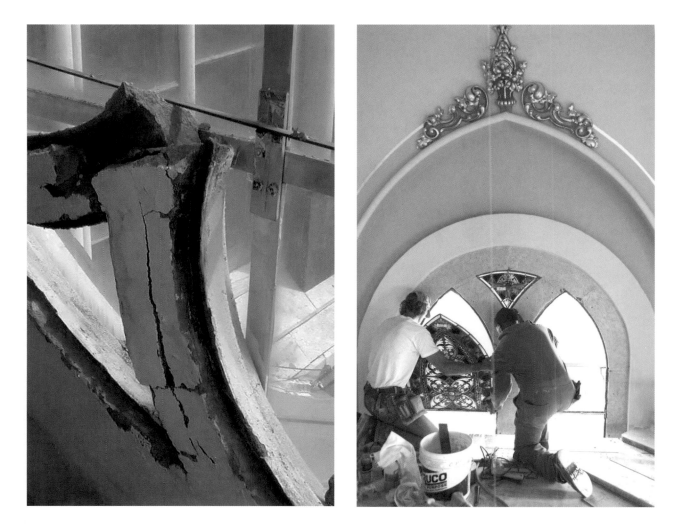

Left: Years of exposure to the elements had resulted in moisture rusting, taking a toll on the concrete frames surrounding the stained glass. The concrete frames were rebuilt prior to installing the glass. Also shown in this photo is the protection glass that remained in place during the restoration process, providing weather protection to the structure during the time that the stained glass was removed. Vent holes were added to the frames to vent the space between the stained glass and the protection glass, adding longevity to the stained glass. Right: Sheridan workers install a window panel in the upper transept above the Sacred Heart Altar.

window glass sitting in five gallon buckets of cleaning solution, even though I knew exactly how we would get them all back in the same spot one day. After soaking, each piece was then cleaned by hand with a scraper and toothbrush, rinsed, and put back on the rubbing, ready for reassembly.

The broken pieces were duplicated, a process that imitated the above-mentioned procedures. Duplication is one of the most painstaking and artistic parts of the whole process. Once a window has all its parts cleaned and broken pieces replaced, it is ready to be reassembled with new lead. (We made the conscious decision to replace rather than reglue the broken pieces. In some restoration circles this is considered sacrilegious, but the feeling of the Church is that we wanted to see the windows as our ancestors one hundred years before saw them.) In the meantime, the craftsmen who removed the windows carefully cleaned and repaired the concrete frames, some of which were damaged quite severely due to moisture rusting, thus expanding the steel reinforcement inside the frame. This expansion "exploded" the concrete so extensive repairs had to be made to some of them. Then the workers made plywood templates of each panel so that the person reassembling the panel

would know exactly what size the new panel had to be. The design of every panel is such that the outer perimeter of glass can be trimmed if necessary without damaging the artistic part of the window.

The lead alloy we used was particularly hard and therefore strong. This material is good for strength but it makes it hard on the artist who puts the glass back together because the bends around the glass are more difficult to make. When the glass panel is assembled it is then cemented with a compound rubbed between the glass and the lead and left undisturbed for a week before it is crated for shipment back to the job. All along the way, the original label, put on when the panel was removed, followed the glass so that each panel would go back in its original location.

We were fortunate that no heads or hands were broken, St. Cecilia's face being the only exception. Other glass was another story. There were over three hundred bullet holes in the rose window alone. And in the other windows there were a few thousand broken pieces of glass. Most of this was common edge glass, but a few were more significant pieces. Each and every piece was handled many times by hand and all of them ended up right back where they started.

The cleaned and restored windows are truly something one has to see in person to appreciate.

A NEW LIGHTING SYSTEM

Chris R. Sheridan Jr.

The new lighting system consists of over 195 fixtures providing over 65,000 watts of lighting. These fixtures are controlled by a dimming system that groups them into forty-eight different circuits that can be individually set from zero to 100 percent of power. There is a master control panel that can be operated by the organist as well as three stations around the Church that can be programmed for various combinations of lighting levels for each circuit. These are known as scenes. This system replaced hanging lights that were installed in 1941 and adds lots of light for reading, along with the ability to adjust the mood of the Church to fit various parts of the liturgy. It was designed by Rohn Design Group and installed by Macon Power Inc. of Macon.

Of particular interest to some of us was how to back light the stained glass window of the Holy Spirit at the top of the cupola. This window was a change from the bland window that had been there since a cupola fire in 1951 and that had no religious, historic, or artistic merit. It was made by copying part of the top of a window in the nave. We photographed a portion of the nave window and used a photo editing program to

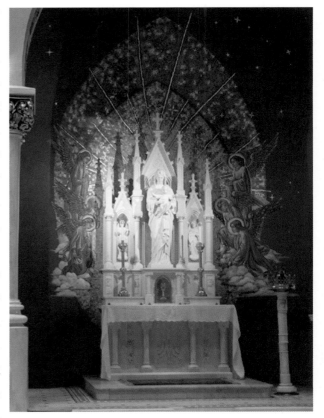

Above, New and better lighting focuses on the altar of the Blessed Mother, surrounded now by beautiful fresco and complemented by a band of angels. Opposite, medallions, acanthus leaves, and brilliant hues of the rose window shine following cleaning, painting, and new lighting.

56

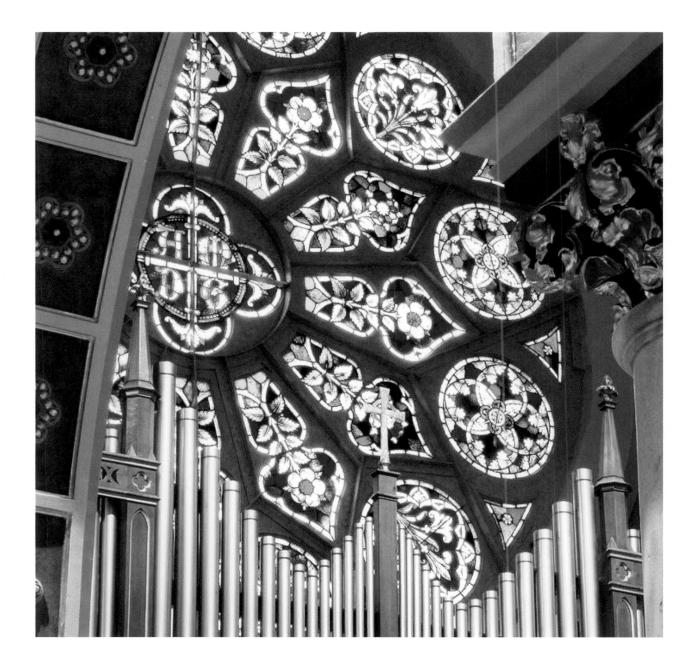

make some modifications needed due to its different location and printed a full size image. That image was sent to Germany, where a stained glass artist made the glass pieces from the full size image. The artist then sent the pieces back to the United States where they were leaded and placed in the Church.

There are four sections of glass lying in a segmented circular steel frame with tempered protection glass on the bottom side. This glass can only be accessed when there is a scaffold tower rising eighty-seven feet from the sanctuary floor so most likely at least another fifty years or so will pass before that happens.

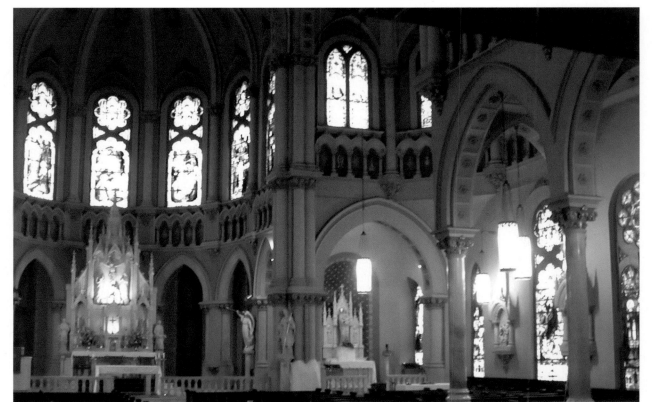

This 'before' photo shows the old lighting. The hanging fixtures that were installed around 1943 caused several problems: they did not produce enough light; they could not be dimmed at certain times; and they blocked views of the Stations of the Cross and the stained glass windows in the nave. Other fixtures also hung in the arches and the transept, distracting the eye from the beautiful, lofty space envisioned by the original architect. The lighting around the altar cast harsh shadows. All of these issues were addressed with the new system.

This presents a problem because we needed to back light the window so it could be viewed in its full glory. How will we change the light bulb when there is no attic access? With a lot of help from the engineers at Macon Power, we devised a metal halide fixture with a 20,000-hour bulb which should last about ten calendar years. That fixture is hanging on a trapeze that can be accessed from a crane on the exterior of the building. We figured that that same crane would most likely be there every ten years or so to paint and touch up the waterproofing of the building, and during that time the bulb could be changed.

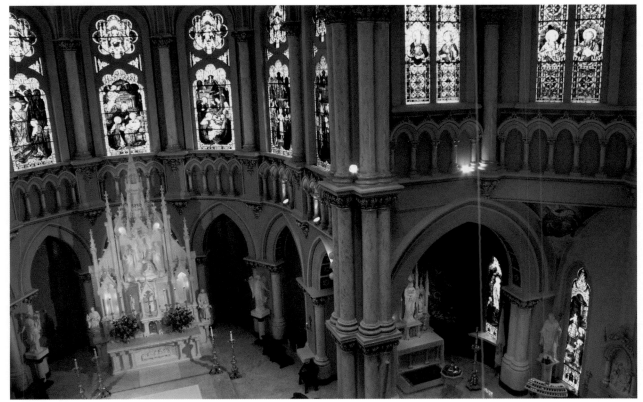

The sconces in the band of small arches at about forty feet high illuminate the ceiling and the gold leaf shadow lines.

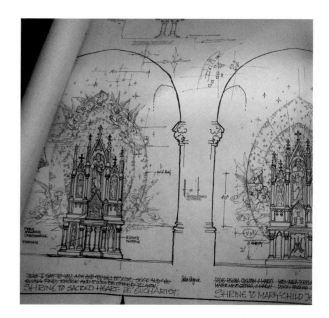

PREPARATION AND PLANNING

Chris R. Sheridan Jr.

As mentioned previously, for as long as I can remember, my father helped maintain the Church. When it came to any painting that needed to be done, he would always work with Mr. A. T. Long and his son, Tony, who also was in the business. Over time, Tony became much more than a commercial painter. He became an artist in his own right. Tony was able to handle many complex painting and decorating projects. Thus when discussions began about repainting St. Joseph, Tony Long was one of the first people I called. He and Patty Downs became a small committee, along with Rolf Rohn and others. It took a while for each of the three artists to get to know each other and each other's abilities. It was my job to keep the group on task, but as their knowledge of each other grew, so did a mutual respect. Out of that professional camaraderie came a new renovation and decoration plan. Tony first carefully did forensic work to uncover the previous decorating schemes in the Church, four of which were documented. Each of these schemes was visible after carefully removing coats of paint that hid them. The original scheme was of the Victorian time of the initial construction and consisted of browns, golds, and dark greens for the most part. It was a very drab and dark approach. In 1918 decorator J.G. Degering described a new color scheme in *The Macon News* (January 27, 1918) as "a neutralistic tone of rich old gold and soft restful greys in the sanctuary..." The next scheme came most likely in the 1940s and was quite different. The walls were rose with very ornate lime green and vermillion accents and very decorative painting around each window frame. The ceiling was light blue. The fourth scheme dates around 1953. In this scheme the main colors were rose and beige. The fifth scheme is the one visible today.

The new scheme was an effort to honor Monsignor Cuddy's desire for the Church to remain a peaceful place of prayer and to accent the wonderful architectural plaster that was not as noticeable under previous schemes. The new scheme also had to work with the new lighting system and had to complement

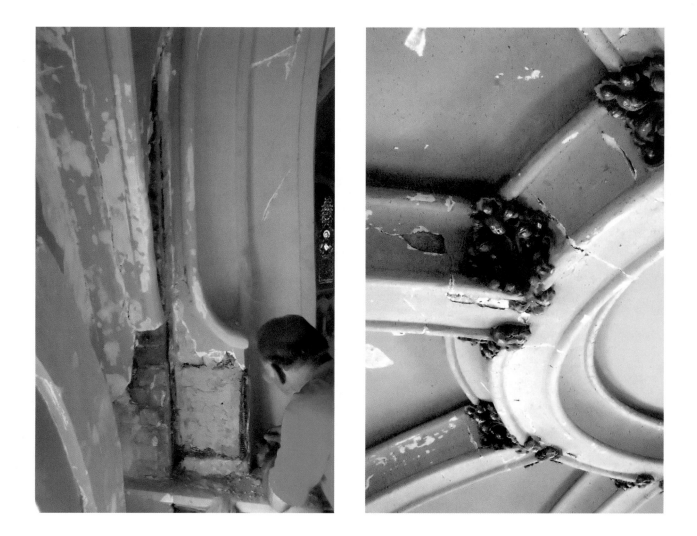

Left: Tony Long examines plaster damage in preparation for restoration.
Right: Workers repaired damage to the plaster, then gold-leaf was applied to the leaves (seen here in red).

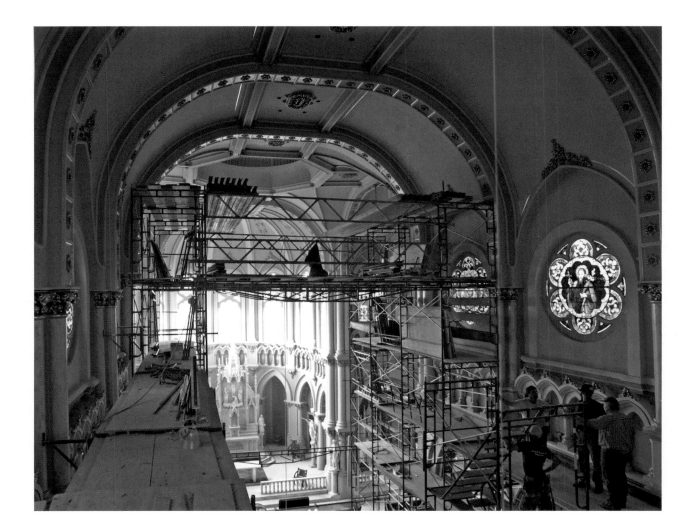

Scaffolding remained in the church well over a year as painters and artists worked to complete the project.

Other examples of the original color scheme: The photo above left is taken in the Southeast Transept over the window of Saints Thomas and Mathias. The photo at right is taken at the ceiling level at the rear of the church under the choir loft and above the window of Our Lady of Sorrows.

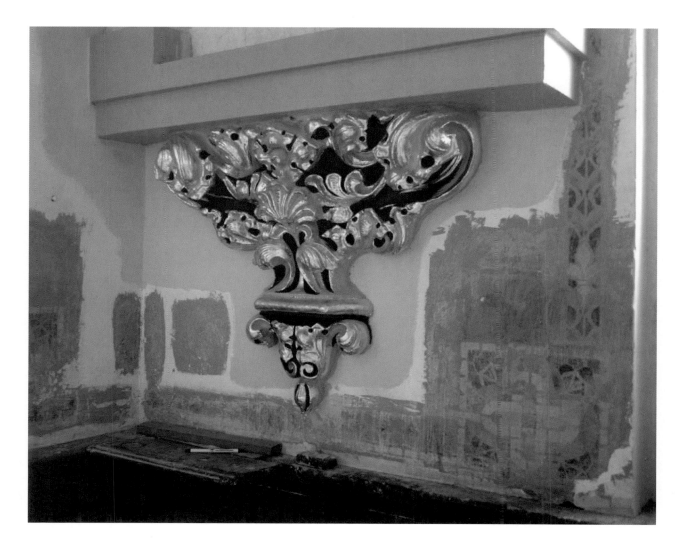

This photo was taken in the rear of the Church close to the new elevator, and it shows two of the previous color schemes. The first documented complete painting scheme used in the church came in 1918 and was generally brown and olive in tone. Around 1943 a much brighter scheme with colors of rose, reds, blues, and lime greens was installed; both schemes appear here. These schemes were carefully documented and photographed before any work was done. A clear coat was then put over what had been uncovered so future generations can access them if desired.

66

This photo is taken in the rear corner of the Church by the door going to the steps that led to the choir loft. The dark area in the upper left is the original color scheme; the rose, red, blue, and green scheme is on top of that.

Evidence of an earlier decorating scheme, including a Greek key design, dates to sometime between 1916 and 1943.

The brilliant reds and blues of the scaffolding are all part of a lively color scheme in this close-up shot of the gold-leafed acanthus.

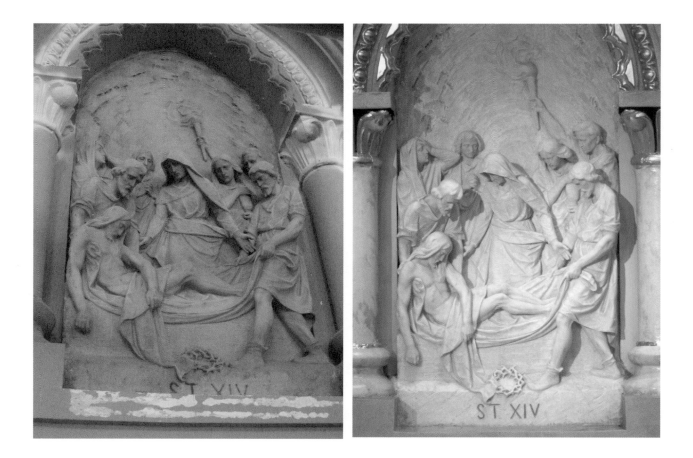

Part of the process included cleaning the marble. Shown here are 'before' and 'after' photos of the process. The hand carved scenes went from a dull gray to a brilliant white. The Stations of the Cross were further enhanced with gold leaf accents and spot lighting on each Station.

and not compete with the stained glass windows.

There were several issues that came up during the process. First, we were asked to work on the Church while also keeping it open. We tried this for four months before we realized that the constant need to work around a busy Church was slowing progress too much. So the celebration of Mass was moved to the Social Hall. Normally decoration begins around the altar area, as this is the most important part of the whole Church. Plus, all original schemes should be tweaked as they are installed. In St. Joseph's case, Tony, Rolf, and Patty Downs put on several large samples and adjusted various lines of color before arriving at the final choice. The process was much slower than might have been done otherwise, but everyone's passion for the work overpowered their desire for a quick result.

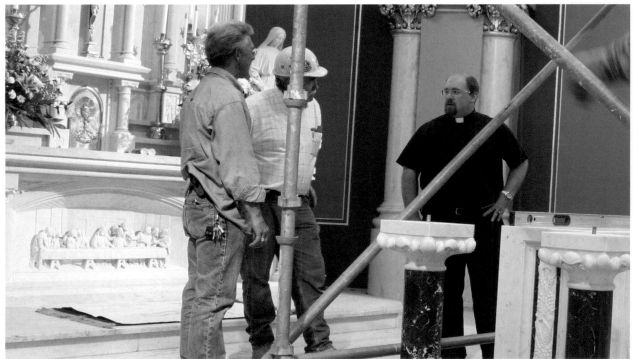

Father Dan Firmin confers with construction superintendent Dennis Tindal and St. Joseph's maintenance supervisor Larry Witt as they work around the High Altar.

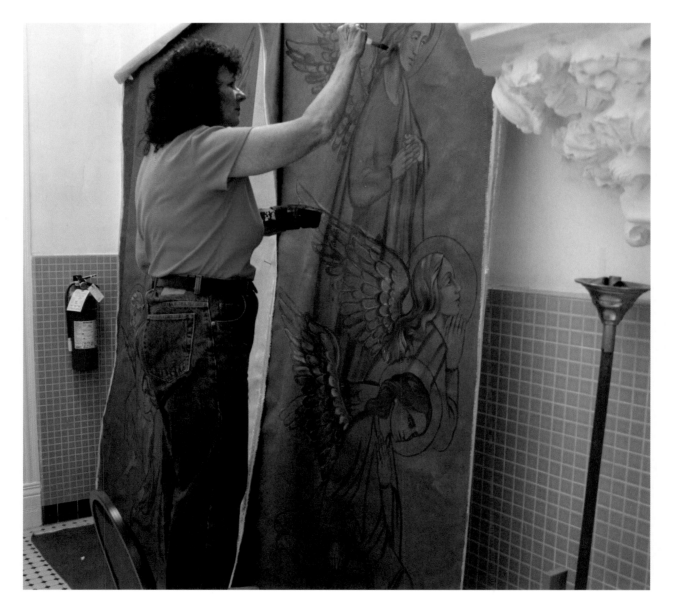

Renate Rohn, shown here, is working on the angels to go behind the Blessed Mother Altar.

71

Painting And Decorative Finishes
Tony Long

To begin the decorative process, Rolf Rohn of Rohn Design Group, Patty Downs, and I had to develop a scheme at the rear of the Church that would work equally well at the altar. Many things had to be considered to achieve just the right combination of color. Colors that complemented the windows were crucial; the windows are the primary decorative element in the space. If we chose the blues, reds, purples, greens, and golds, did we want to use them as a major color, or as accents? Bold or subtle? How light or dark should the basic colors be on the walls and ceilings? Our first approved sample was from one of the bays of a side aisle. After the scaffold was built in the rear nave, we used the sample colors on the upper nave. That did not work. So the process started over. We changed colors for this upper area so that when we brought them down to the lower areas the overall effect would be peaceful.

Lighting was our nemesis. In order to make any sort of schedule we had to remove the stained glass windows. The amount of light and its color were vastly different in the Church with those windows removed. We would apply colors on a large sample area that looked great in the afternoon, either up on the scaffolding or from the floor. The next morning it looked different and usually not better, but worse. This difficult situation went on for a couple of weeks before combinations began to look satisfactory. What we had to do was to choose colors in the bright light of a Church with no stained glass and anticipate how it would look when the windows were back in place, and with a new lighting system to boot. We finally reached the point that we were tweaking an accent color and moving accent colors around, or applying a glaze to make a subtle change. When we brought these colors down to a lower level, they worked by changing the depth of color slightly. We found that we could use the darker blue on the side aisle ceilings and on the flowers on the bottom of the beams, especially when we softened the dark blues with glazes.

With a color scheme decided, work could

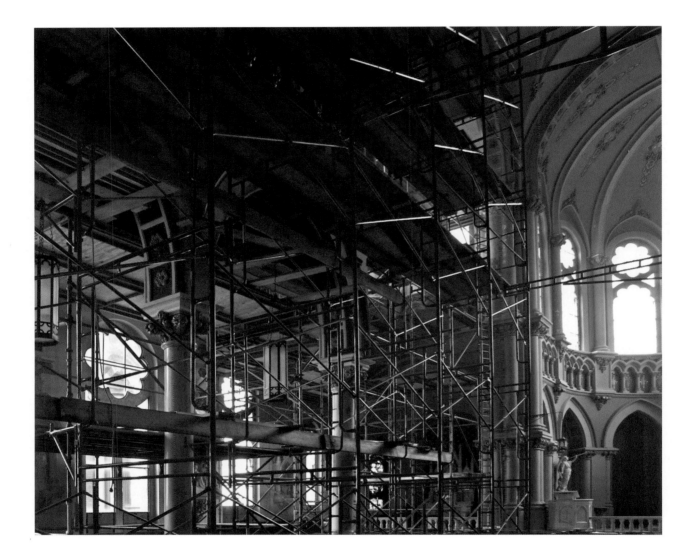

Note how the light changes when the stained glass windows are removed from the Sanctuary. The space remained protected by plexiglass covering.

73

After all the work was completed, the artists returned for this group picture. From left, they are Craig Burkhalter, David Sutton, Katy Olmsted, Maryann Bates, and Ray Snyder.

begin. I assembled a group of artists who, along with my paint crew, worked to implement the plan. This was a very creative experience for everyone involved, thanks to Rolf Rohn's extensive knowledge of Church liturgy and how the architectural and decorative schemes relate to it and therefore enhance worship. With this information, the artists' creative juices flowed; they developed ways to achieve the desired results. We used many types of decorative painting: 24K gold leafing, marbleizing, glaze finishes, wood graining, stenciling, and stone finishes.

Each of the artists involved in the project— Maryann Bates, Katy Olmsted, David Sutton, Ray Snyder, and Craig Burkhalter—brought an expertise to the project and took the lead in their areas of decorative painting. The paint crew was experienced and motivated by the grandness of this project to do their very best. They did all the prep work and applied the base coats for the decorative painting, as well as all the finish painting. The lead painter, Charles Solomon, knew each color and where it was to be applied.

The paint crew was responsible for removing loose plaster that had been located and marked by several of us. They then primed, with an oil

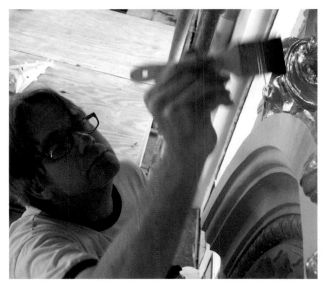

Artist Craig Burkhalter applies gold leaf to acanthus leaves.

based stain block, all remaining plaster, including the plaster base coat in areas where the skim coat of plaster had fallen off or been removed because it was loose. After that, the plasterers came and re-plastered all those areas. The lead plasterer, Willy Durham, and I made molds of all the decorative elements that needed replacing. Some of the damage was the result of water seepage, some from structural vibration, and some from past work. There was an extensive amount

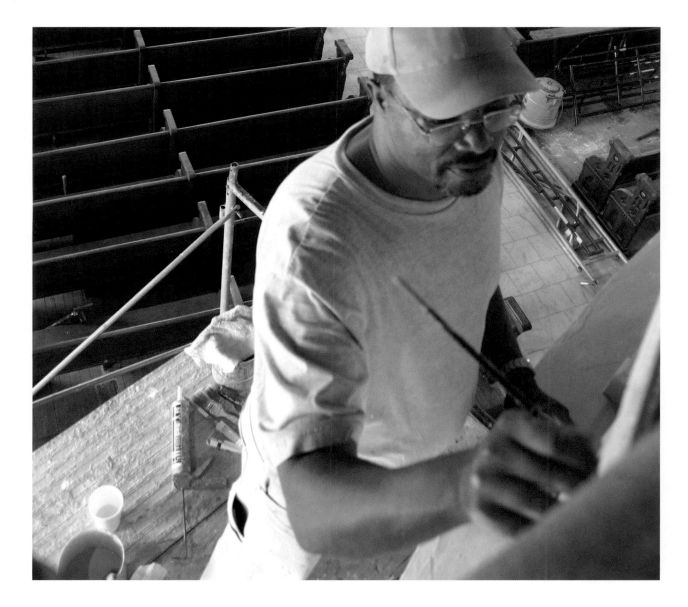

Charles Solomon applies decorative painting around the choir loft. Church pews are in the rear, below the scaffolding.

Amid all the chaos lies a testament to planning and attention to detail.

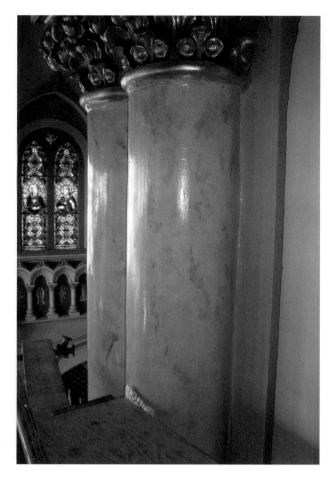

The eight center columns in the church are marble. The remaining ones, made of plaster, were marbleized during renovation, to grand effect as seen here.

of flat plaster and decorative plaster work done.

After all the plaster was repaired and given adequate cure time, another coat of oil based stain block was applied. Then two to three coats of acrylic paint were applied in either a flat, eggshell, or semi-gloss finish. Walls, moldings, and ceilings were given three coats of a flat finish. Decorative items that were being glazed received an eggshell finish since they were only partially covered with the glaze. This was the way the ceilings on the sides of the Church at the arches were completed. Semi-gloss was used on all pieces that were to be completely glazed or gold leafed, e.g., the flowers on the bottom of the beams. The gold leaf striping was done over flat paint, after a latex urethane was applied as a sealer to the area to be gold leafed. Column capitals and brackets were painted with a semi-gloss finish. Next, glaze was applied in certain areas, then the gold leaf was applied. Background colors were added in a flat finish.

All the doors in the nave are heart pine and had to be wood grained to match the oak wainscot and pews, as well as the massive oak front doors. The eight center columns are Georgia marble. All of the other columns are plaster, and as far back as I can recall, there has been a desire to marbleize

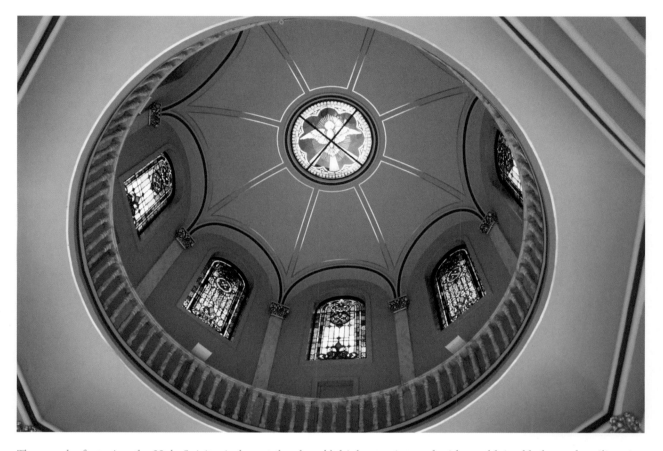

The cupola, featuring the Holy Spirit window at the church's highest point, and with marbleized balustrade railing, is surrounded by glorious new stained glass windows, designed in Germany and made in the United States.

them. We did, and they make a beautiful statement about the magnificence of St. Joseph Church. The frames around the stained glass windows are concrete and have always been painted a dark color, gray or black. We came up with a medium tan stone finish that allows the full color of the stained glass windows to be enjoyed without a distracting dark frame.

When we moved from the back of the nave to the transepts and sanctuary, we realized that there were areas that required different treatments and special attention, such as the

cupola, the evangelists, the sanctuary, Sacred Heart Chapel, and the Blessed Mother Chapel. Each of these presented a new challenge.

The cupola had to be treated differently because it is separate from the main part of the ceiling. In the center of the crossing, the cupola is the highest point (eighty-seven feet) inside the Church. We did not introduce any new shades of color; however, we did darken some of the lighter tones to compensate for the additional light. We also made all of our accent lines wider so they could be seen at that height. And, we had to solve an optical illusion.

The cupola is situated at the top of a coved ceiling. It is octagonal at its juncture with the main ceiling, and as it rises toward the cupola, it becomes a circle at the base. There is a railing balustrade above this circle. We decided to marbleize the pickets and railing and paint a six-inch wide dark band underneath them on the coved ceiling to give the railing the appearance of sitting on a base. I drew the line all the way around, using the inner circle as a guide. When painted, the circle appeared as a six-inch line with eight arrows pointing at the floor. Even though each corner of the octagon was only six inches

from the inner circle, there was the illusion that the octagon came to a point three inches below the circle. To correct this, the line at each of these points had to be drawn one-and-one-half inches toward the inner circle in a cone shape.

When we started the transepts, we began discussing the four evangelists. We decided on a full figure, fresco style, and began looking for someone to execute the paintings for us on canvas. Jim Stallings recommended Sean Crosby, an artist in New York City, who was hired to paint and install four murals of the Evangelists. A local wallpaper hanger, Leon Simmons, and I helped put them on the ceiling. After they were hung, we applied a plaster-like resin around the edges of the canvas and over the background area. Rolf's sister, Renate, and I did the background around the evangelists.

The sanctuary was a major undertaking. The marble railing between the altar and the nave was removed, the steps were extended, and the floor raised. There is a new marble altar table, a new pulpit (ambo), and new furnishings. There were a few decorating decisions. We closed the cry room window and a door so that the six niches became uniform. A decoration scheme was chosen for

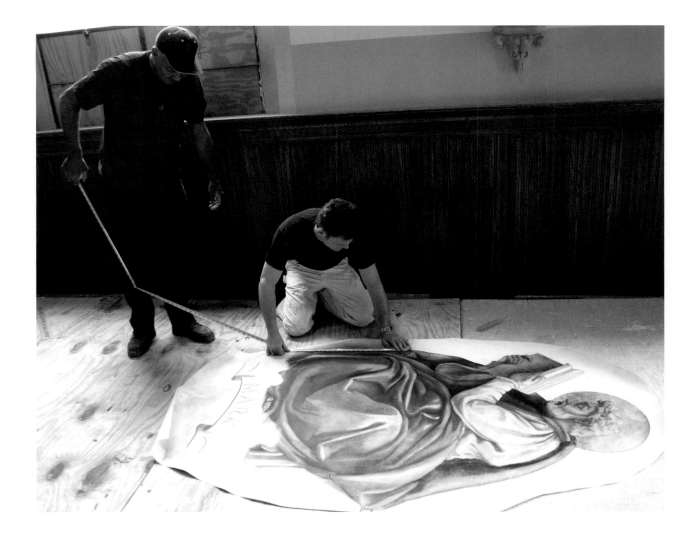

Artist Sean Crosby, kneeling, works on the canvas of St. Mark the Evangelist, with help from Leon Simmons.

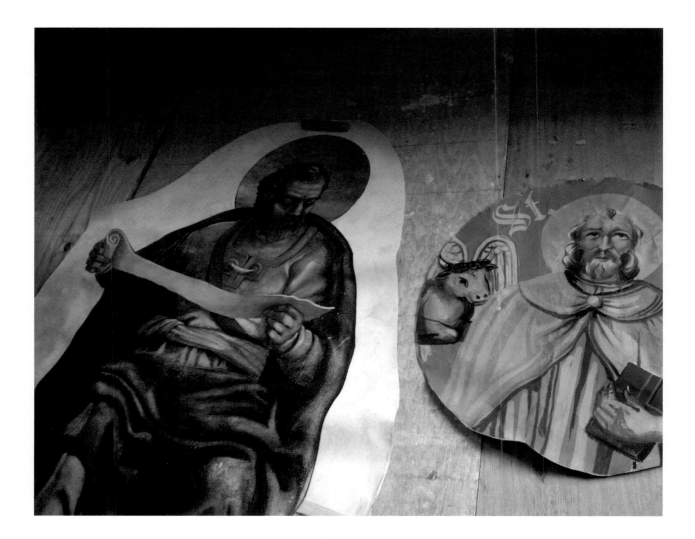

A dramatic new depiction of the evangelist St. Luke, at left, replaces the older image, at right.

A detailed view of an angel, painted by Renate Rohn, one of many surrounding the Blessed Mother altar.

them that introduced a new, deeper, rose color to contrast with the Cararra marble reredos.

The decorating schemes for the Sacred Heart Chapel and the Blessed Mother Chapel are Rolf's. He pointed out that, liturgically, the Sacred Heart is represented as red and the Blessed Mother as blue. He expanded the gold mosaics on the altars in each chapel to the wall behind them to look like sunbursts, and added angels. Renate painted the angels that she had drawn on canvas. We cut them out, and Dudley Shannon of our paint team put them on the wall. The gold mosaics on the wall are gold leaf and were difficult to put on in a very random pattern. Another optical illusion occurred when we drew the cone shapes behind the two altars that would contain the sunbursts. We drew them using a radius point on each side to make the top curves. When we moved back to look at our work, the line had a swag halfway through the top curve. It took us some time to understand the problem. The shape of the rear of the chapel was like an inverted cone with curves coming up from two directions. To solve this problem, Craig Coleman, Katy Olmsted's husband, brought in his laptop and a projector. He drew our shape on his laptop and projected it on the back of the chapel. There was our squiggly line. He then moved the squiggly line until it appeared correct. We traced it on the wall from his projection. We now have a line with a hump in it that appears to be a perfect cone.

All the people who worked on this redecoration of St. Joseph Catholic Church are thankful for the opportunity given them to play a part in this truly great work of architecture. We will remember the part we played and we hope that we have, with God's help, created a peaceful place of prayer.

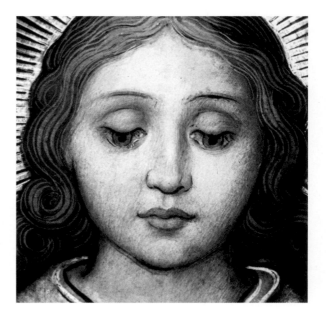

STAINED GLASS: THE WINDOWS OF ST. JOSEPH CHURCH

Joni Woolf

The origins of stained glass date to the first century A.D., when it was considered a domestic luxury rather than an artistic medium. When the Roman Emperor Constantine first permitted Christians to worship openly in AD 313, they began to build churches based on Byzantine models, and glass was an art form used in those buildings.

By the ninth and tenth centuries, the demand for stained glass windows increased as churches flourished. In fact, the earliest surviving example of pictorial stained glass is a Head of Christ from the tenth century excavated from Lorsch Abbey in Germany. Most church windows from that time were depictions of individual figures such as King Hezekiah from Canterbury Cathedral, England, (AD 1220) and Charlemagne enthroned from Strasbourg Cathedral, Austria, (AD 1220). The small windows of the time featured reds and blues surrounded by white glass, letting in as much light as possible.

During the thirteenth and fourteenth centuries, stained glass flourished as the expansion of immense window spaces in Gothic cathedrals called for a new approach. Although red and blue continued to be predominant color choices, the artists now filled the space with ornate designs using darker glass instead of white. More than anyone else, Suger, the abbot of St. Denis from AD 1122 to AD 1151 and confidant to kings Louis VI and Louis VII, helped bring about a revolution in architecture and stained glass that we refer to as the Gothic style. He believed that the presence of beautiful objects would lift souls closer to God. The emergence of the rose window at St. Denis Cathedral and Chartres Cathedral (both in France) exerted great influence throughout Europe. The stories and messages of the Bible could be conveyed to an illiterate populace, teaching them about the life of Christ and the Good News of the Gospel through glass pictures.

The Cistercian Order under St. Bernard found that the figurative windows distracted monks from

religious responsibilities; thus, a shift in taste brought an increase in non-figurative windows and concentric patterning that incorporated more transparent glass. As the palette became increasingly lighter, horizontal layers of colored glass and grisaille (using a range of grays) glazing were incorporated in the figurative windows. The art form further broadened with the widespread use of elaborate stone window tracery (intricate cames with lace-like patterns). Individual figures resurfaced, but they were now framed by architectural canopies. Stained glass witnessed its greatest diversity in design, style, palette, and sentiment during the Gothic period. Regulated guilds and new technological advances elevated stained glass to a position of prominence that would remain unsurpassed.

Political upheavals and religious unrest threatened the priceless art form with extinction during the sixteenth and seventeenth centuries. Reformers destroyed tremendous amounts of glass, particularly in England, and many of the glass factories in Lorraine, France, were devastated by war. At the same time, Renaissance styles began to take precedence over Gothic style. For approximately two hundred years, stained glass fell out of favor, almost becoming a lost art, until its revival in the nineteenth century.

This is when Franz Mayer Studio of Munich, founded in 1847, comes in. According to a fourth generation descendant, Konrad Mayer, Franz Mayer had a school for disabled children, who had no place to work when they finished school at age fifteen. So he founded his art studio to provide work for these children, employing as many as one hundred working on church furnishings. In the years since, the studio has achieved worldwide acclaim, and was named by Pope Leo XIII a "Pontifical Institute of Christian Art." The company has become an international enterprise, designing windows and other furnishings for buildings around the globe. The windows that the studio designed for St. Joseph's defy description, and must be seen—either in person or in beautiful reproductions such as these—to be appreciated fully. The detail provided by the photographic artist brings into stunning perspective the people and events that the windows represent. Seen as never before are the faces of Jesus, his followers, and all the saints who are honored in the breathtaking windows of St. Joseph Catholic Church.

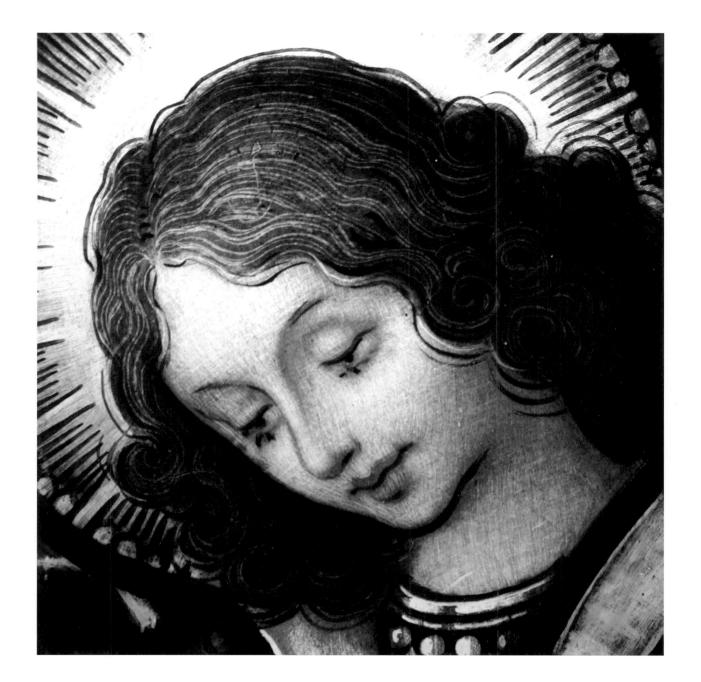

LEFT: ST. TERESA OF AVILA
A Spanish Carmelite nun, she was proclaimed a Doctor of the Church; died in 1582 at the age of sixty-seven.
RIGHT: ST. BRIDGET
One of the first Irish nuns, she died in AD 523 at the age of seventy.

LEFT: ST. ROSE OF LIMA
First South American to be canonized, she died in 1617 at the age of thirty-one.
RIGHT: ST. AGNES
One of thousands who died as Christian martyrs in Rome, she was only twelve years old at the time of her martyrdom in AD 304.

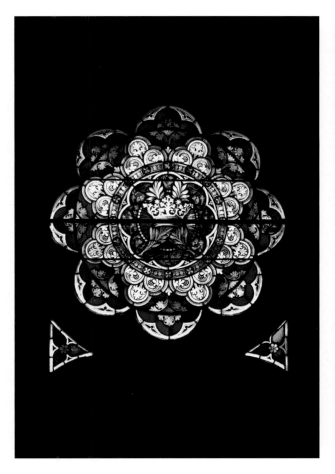

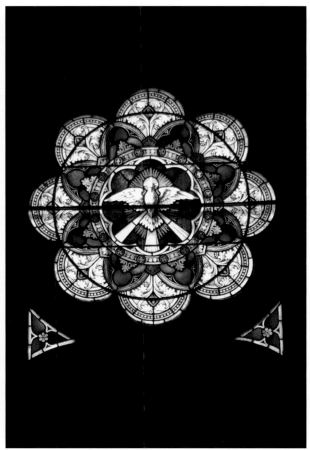

CROWN OF VICTORY AND PALMS. HOLY SPIRIT.

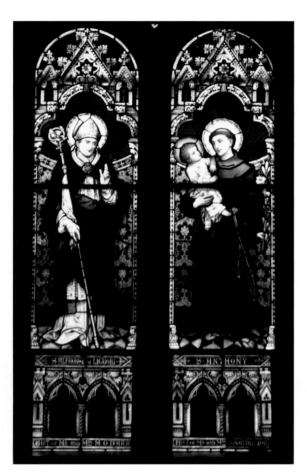

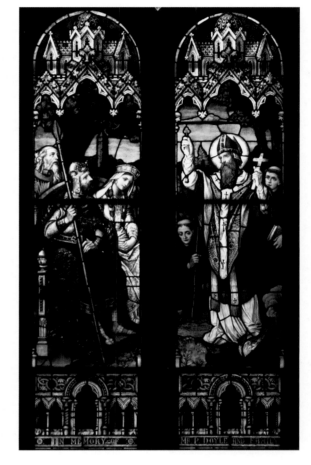

LEFT: ST. ALPHONSUS OF LIGUORI
An Italian bishop, he started the Redemptorist Order;
died in 1787 at the age of ninety.
RIGHT: ST. ANTHONY OF PADUA
A Portuguese Franciscan priest and a Doctor of the
Church, he died in 1231 at the age of eighty-six.

ST. PATRICK
After he was ordained a bishop, Patrick was sent back
to Ireland where, in thirty-three years, he converted the
country. He died there in AD 461 at the age
of seventy-six.

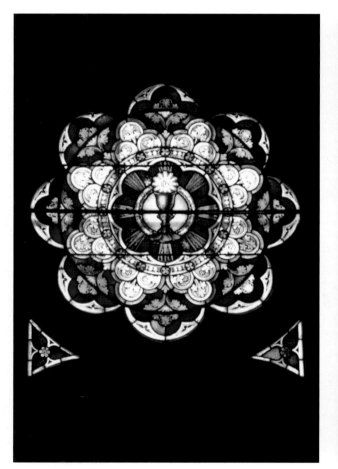

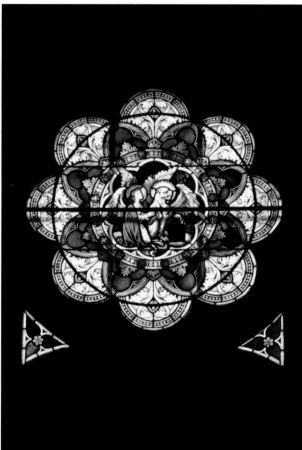

HOLY EUCHARIST.

ANGEL REPRESENTS GOSPEL OF ST. MATTHEW;
LION REPRESENTS GOSPEL OF ST. MARK.

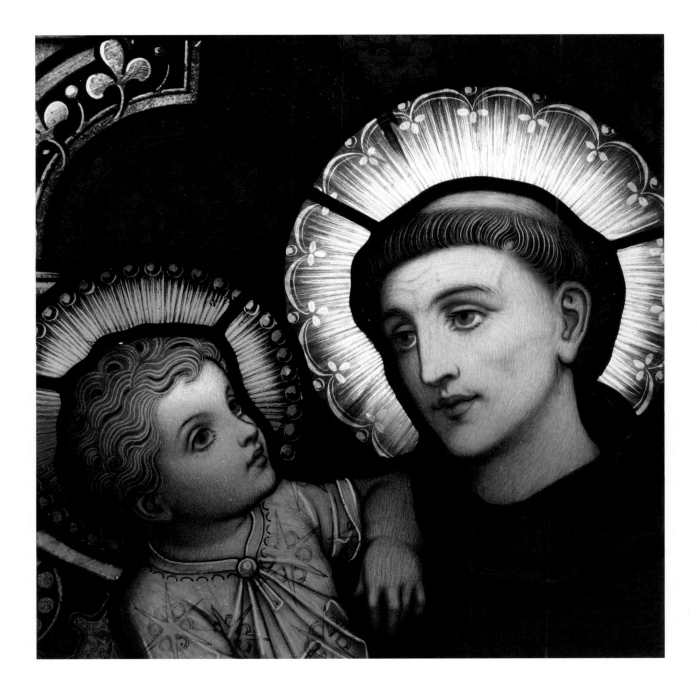

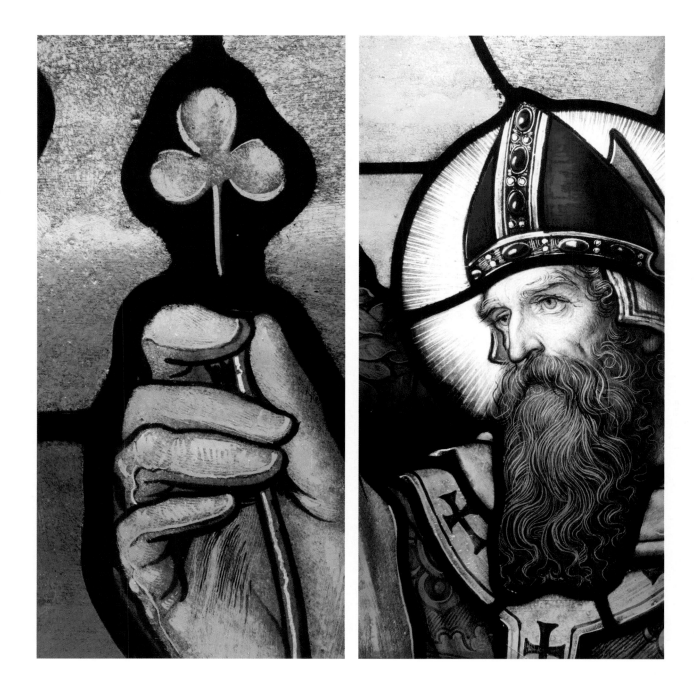

Our lady of Sorrows.

CHRIST WITH CROWN OF THORNS.

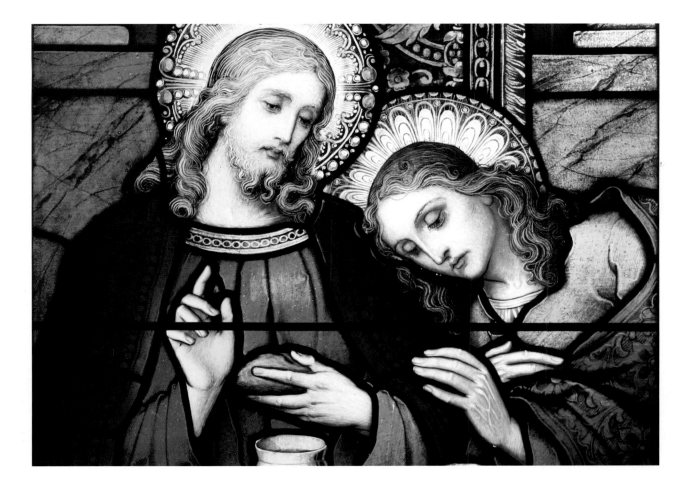

LAST SUPPER WITH BELOVED DISCIPLE. ST. JOHN.

100

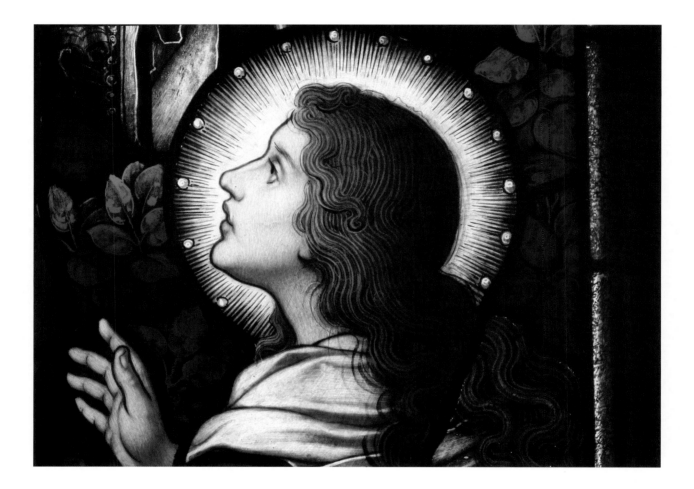

AFTER THE RESURRECTION, CHRIST APPEARS TO MARY MAGDELENE.

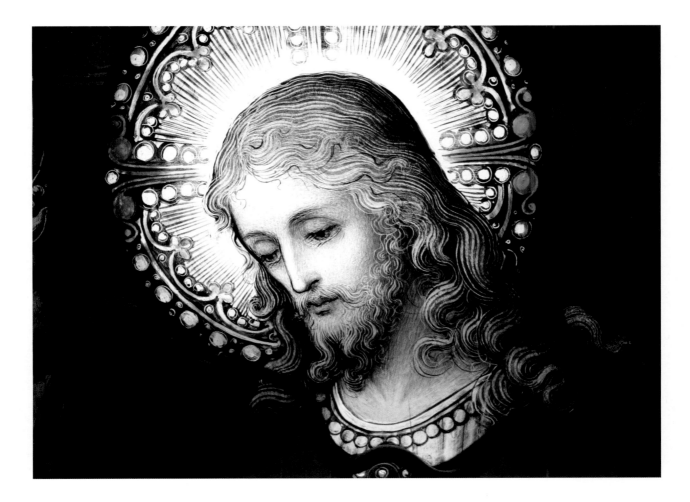

APPARITION OF THE SACRED HEART.

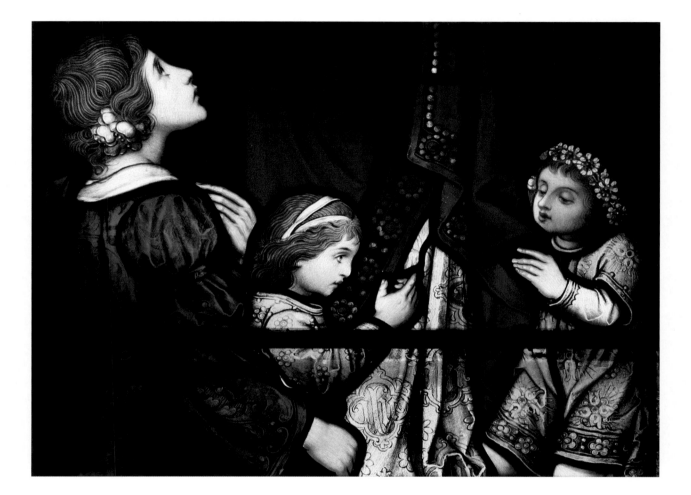

JESUS BLESSES THE LITTLE CHILDREN WHO FLOCK TO HIM.

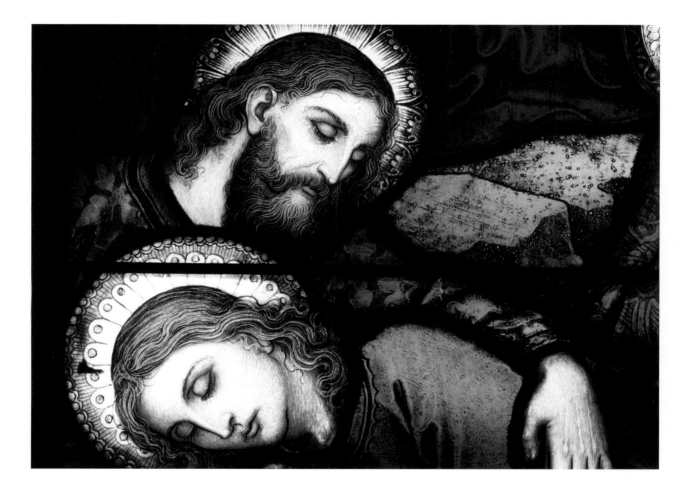

Agony in the Garden of Gethsemane: Jesus prays while St. John, St. Peter, and St. James sleep.

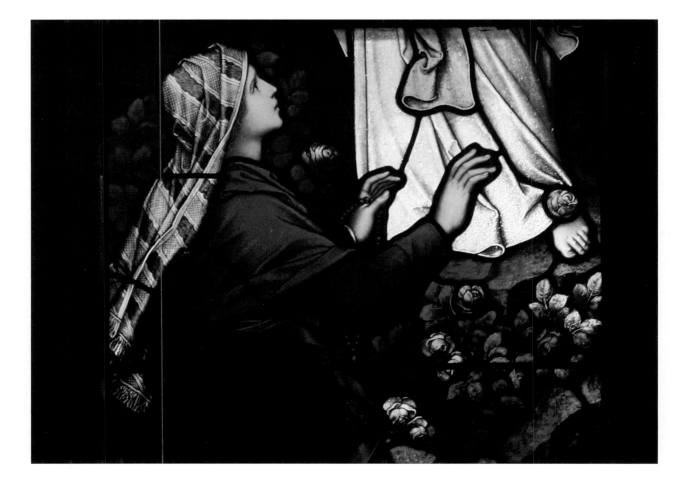

OUR LADY OF LOURDES.
Our Lady appears to St. Bernadette Soubirous in Lourdes, France, in 1858.

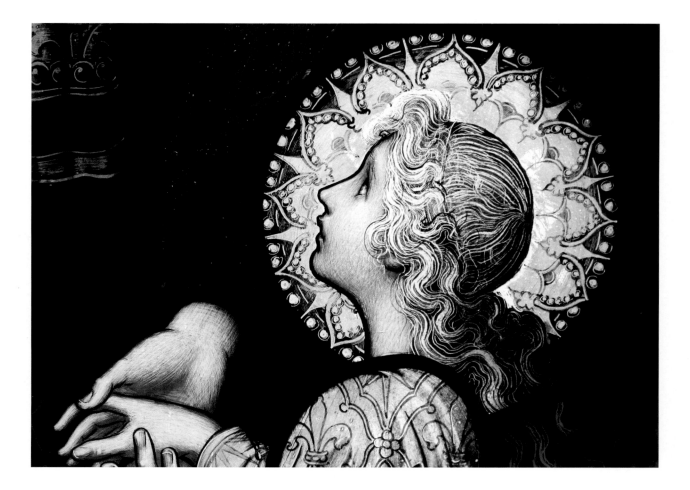

St. Anne presenting Mary in the Temple.

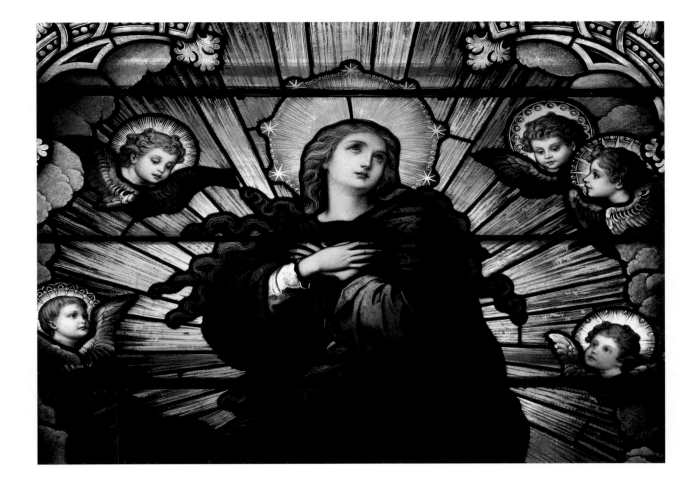

ASSUMPTION OF B.V.M.* (SEE PAGE 186)

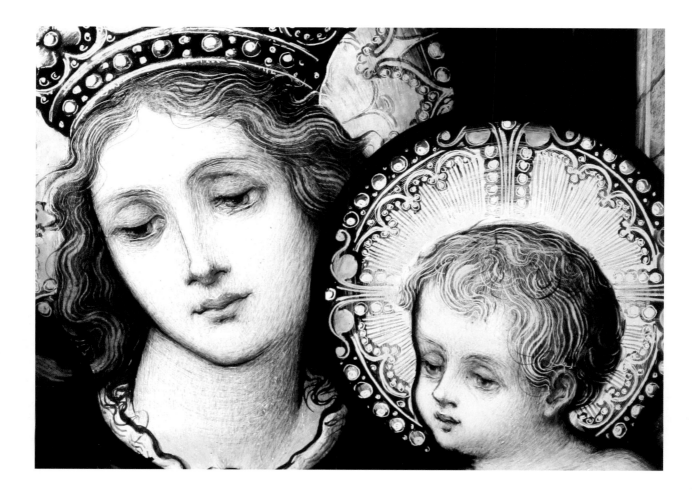

Blessed Mother with the baby Jesus giving rosary to St. Dominic.

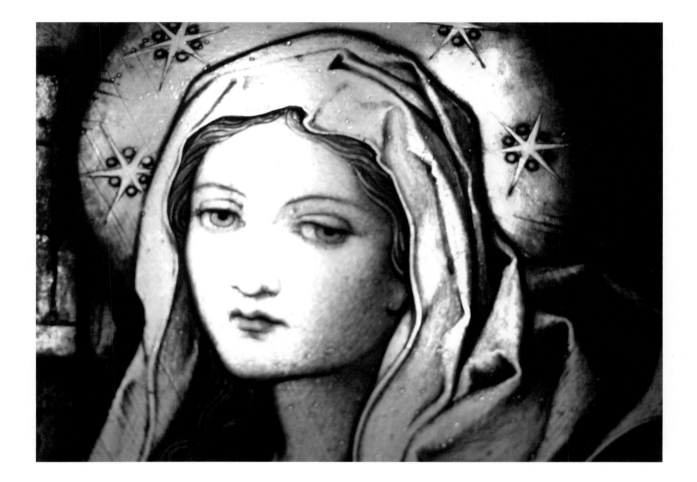

MARY, AS SEEN IN THE HOLY FAMILY WINDOW.

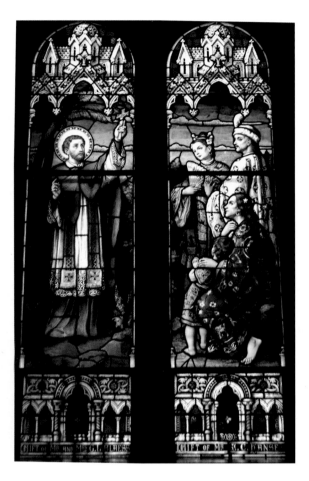

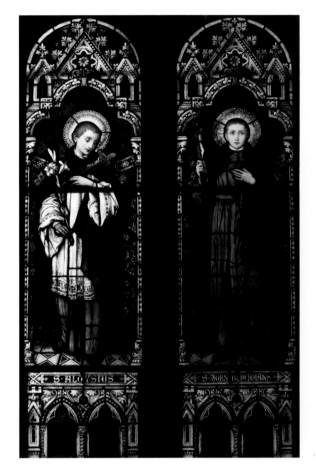

ST. FRANCIS XAVIER
A Spanish Basque Jesuit priest, he preached to the
first Japanese Christians; died at the age of forty-six
off the China coast in 1552.

LEFT: ST. ALOYSIUS GONZAGA
An Italian Jesuit seminarian, he died in Rome in 1591
at the age of twenty-three.
RIGHT: ST. JOHN BERCHMANS
A Flemish Jesuit seminarian, he died in 1621 at the
age of twenty-two.

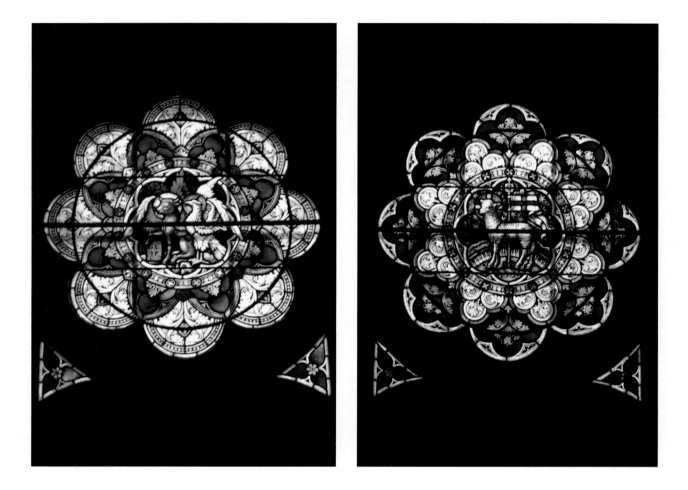

EAGLE REPRESENTS GOSPEL OF ST. JOHN; OX
REPRESENTS GOSPEL OF ST. LUKE.

LAMB OF GOD.

112

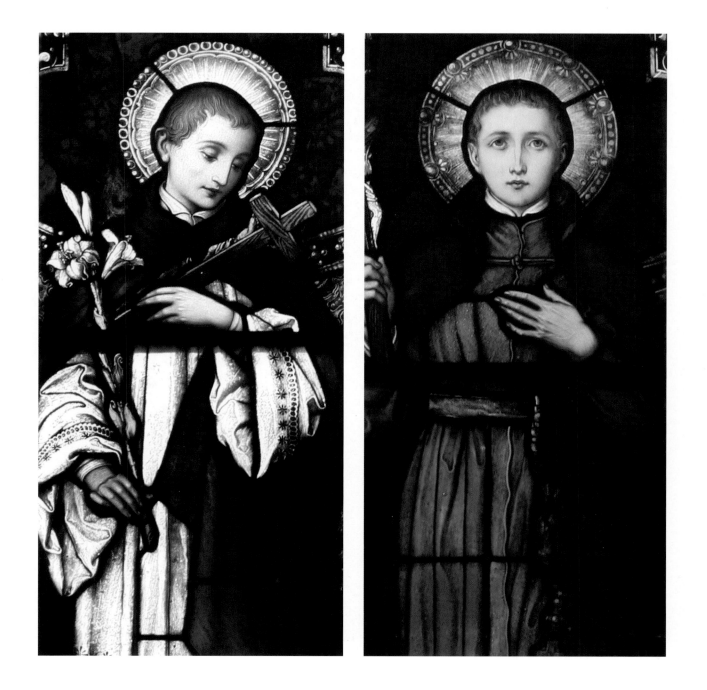

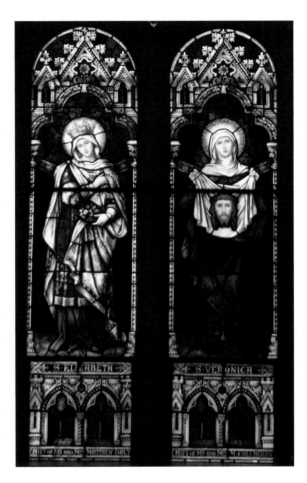

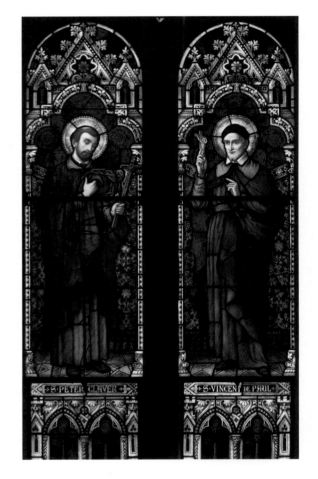

LEFT: ST. ELIZABETH OF HUNGARY
A princess who ministered to the poor, she died as a Franciscan in 1231 at the age of twenty-four.
RIGHT: ST. VERONICA
Legend says she pushed her way through the crowd to wipe the bloody face of Jesus on His way to Calvary.

LEFT: ST. PETER CLAVER
A Spanish Catalan Jesuit priest, he worked among the slaves in South America and died in Colombia in 1654 at the age of seventy-four.
RIGHT: ST. VINCENT DE PAUL
A French secular priest, he started the Vincentian Order to combat poverty; died in Paris in 1660 at the age of eighty.

ADORATION OF THE HOLY EUCHARIST.

KEYS TO THE KINGDOM.

115

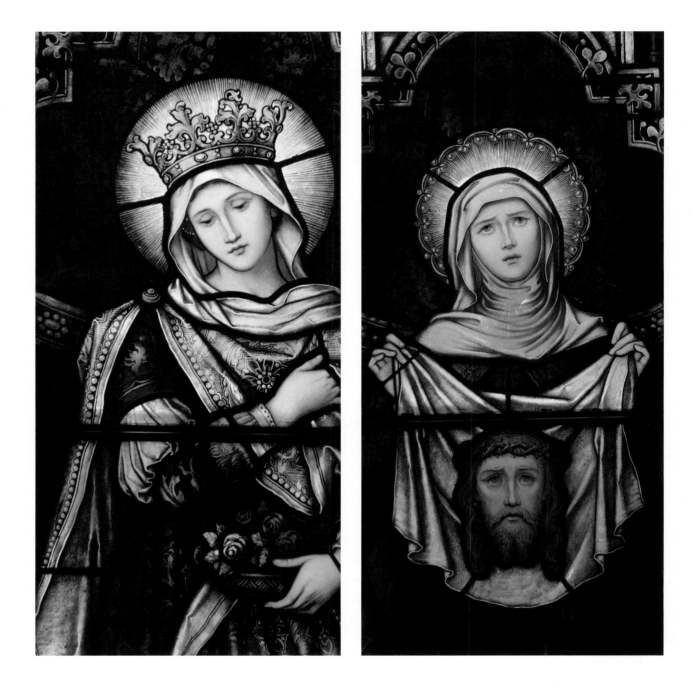

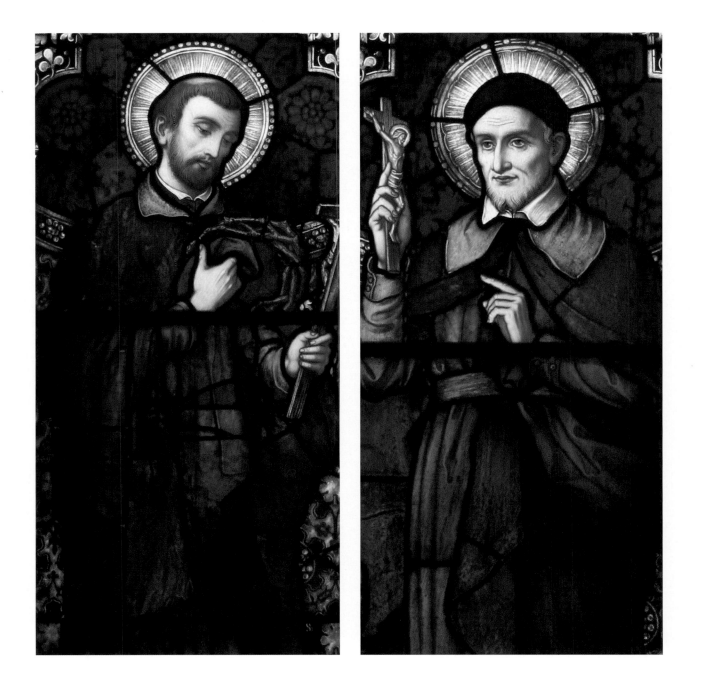

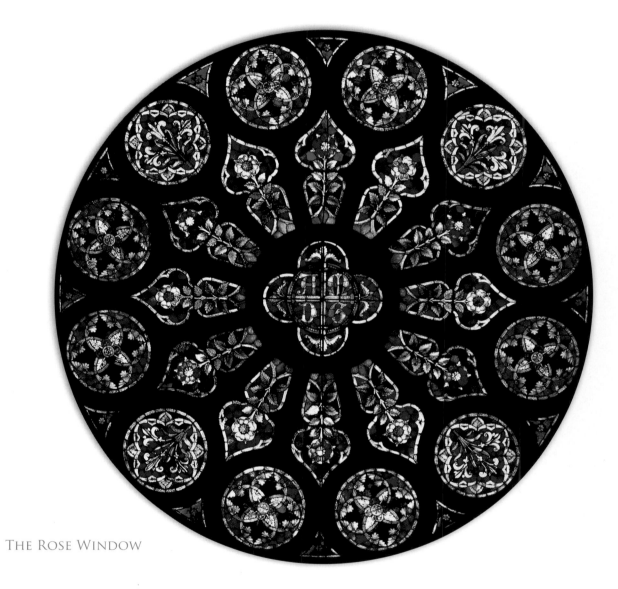

THE ROSE WINDOW

119

ST. MONICA
Mother of St. Augustine, she prayed for twenty years for his conversion; died in Milan, Italy, at the age of sixty-five.

ST. BENEDICT
An Italian monk, he founded the Benedictine order; died ca. AD 547 at the age of sixty-seven.

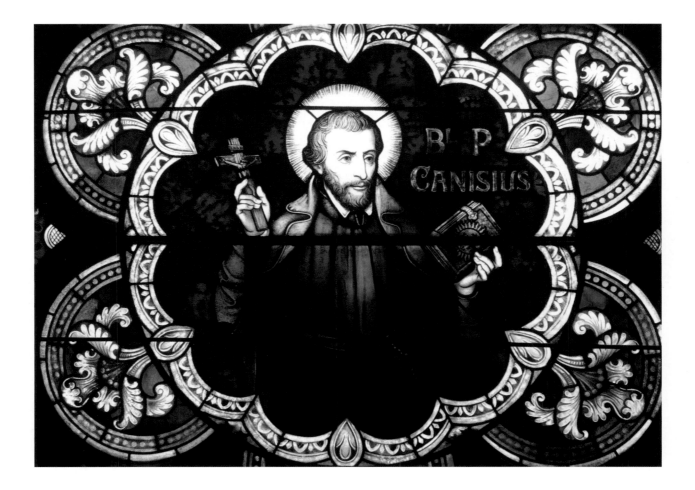

ST. PETER CANISIUS
A Dutch Jesuit priest and a Doctor of the Church, he helped stem the German Reformation. He died in 1597 at the age of seventy-six.

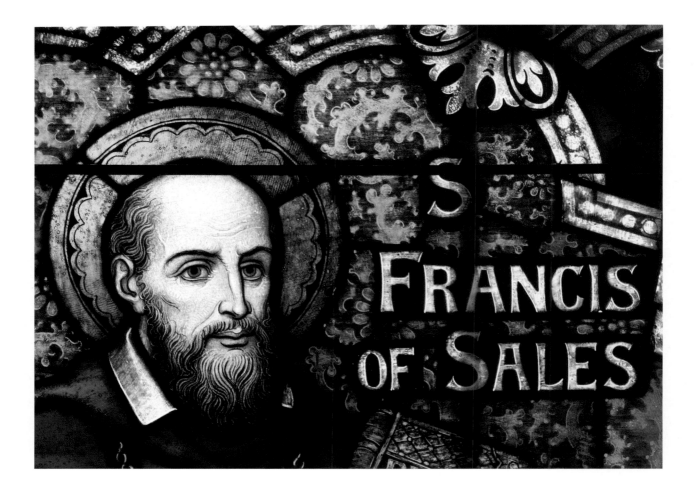

122

ST. FRANCIS DE SALES
French Bishop of Geneva, Switzerland, he is a Doctor of the Church; died in 1622 at the age of fifty-five.

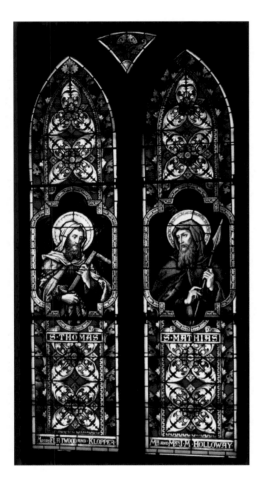 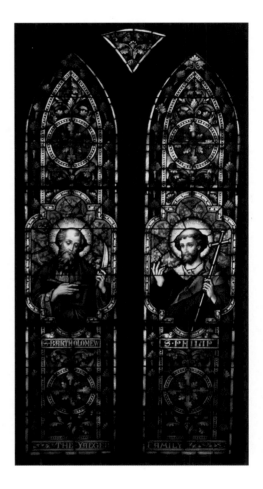

LEFT: ST. THOMAS
Known as the doubting Apostle, he died as a martyr in ca. AD 72 India.
RIGHT: ST. MATTHIAS
The Apostle chosen to replace Judas Iscariot. He was martyred in Colchis in AD 80.

LEFT: ST. BARTHOLOMEW
Sometimes called Nathaniel, this Apostle was martyred in Armenia.
RIGHT: ST. PHILIP
An Apostle, he was crucified upside down in Greece.

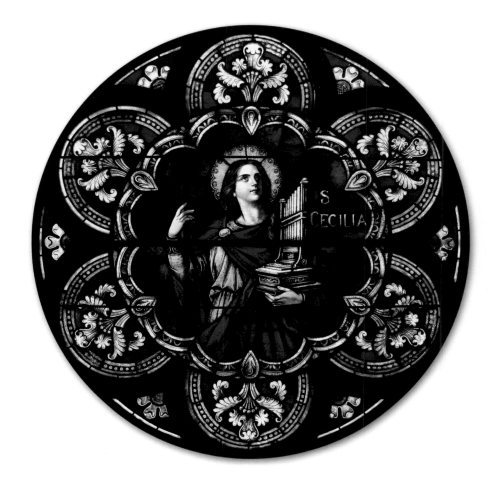

ST. CECELIA
A Roman maiden who loved music, she was martyred ca. AD 250.

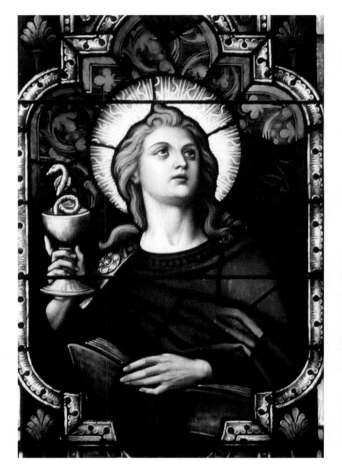

ST. JOHN
Called "the disciple whom Jesus loved," the Apostle John
has four New Testament books attributed to him. He died
in AD 100 in Ephesus.

ST. ANDREW
An Apostle and the brother of St. Peter, he was crucified
in Patras, Greece. He died on an X-shaped cross
ca. AD 80.

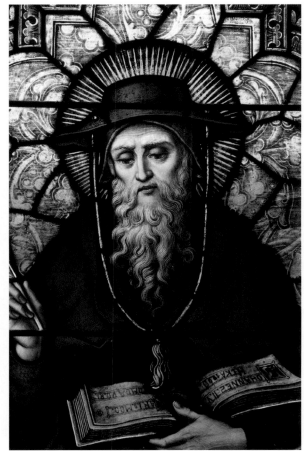

ST. GREGORY THE GREAT
An Italian, he was pope from AD 590 to AD 604, and sent
missionaries to the then pagan Anglo-Saxons; died at the
age of sixty-four.

ST. JEROME
A Dalmation priest, he is famous for translating the entire
Bible into Latin; died in AD 420 at the age of
seventy-eight.

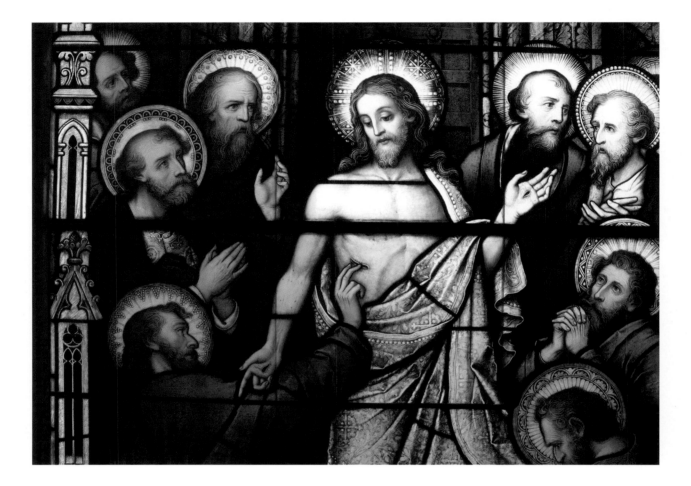

OUR LORD APPEARS TO ST. THOMAS.

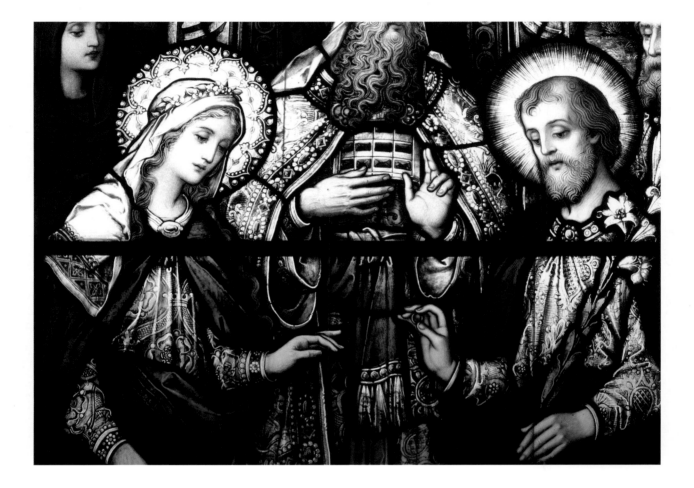

THE MARRIAGE OF MARY AND JOSEPH.

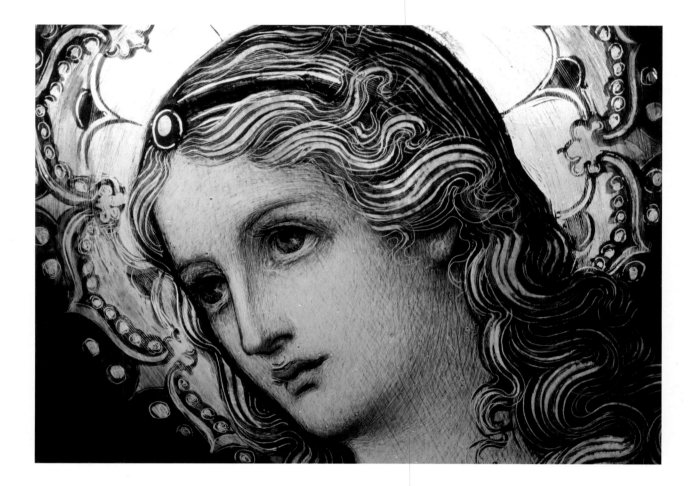

THE ANNUNCIATION.

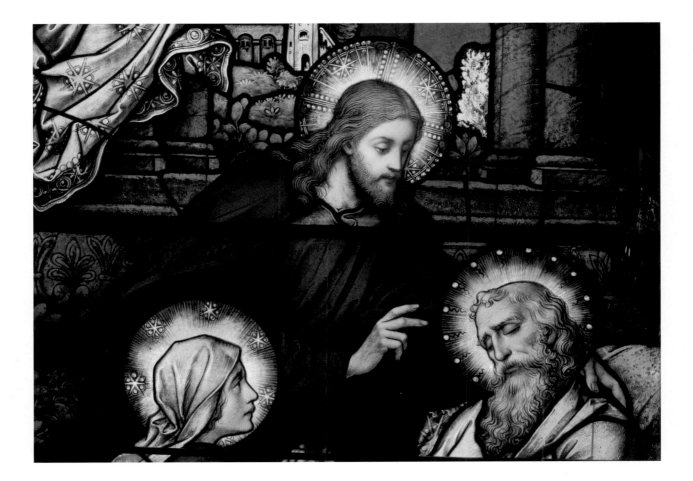

The Death of St. Joseph.

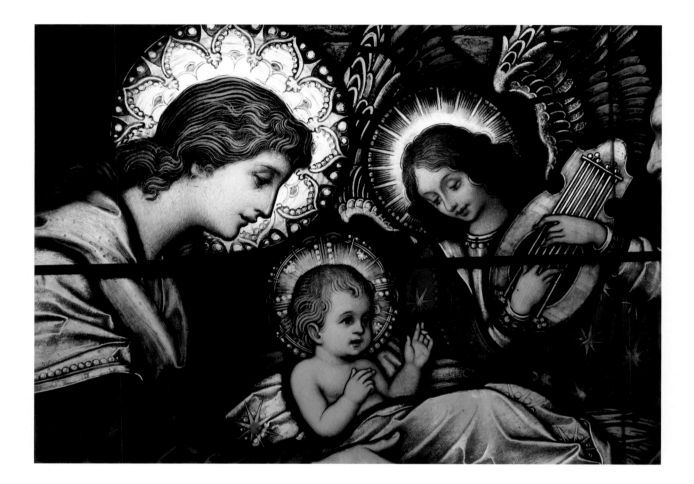

THE NATIVITY.

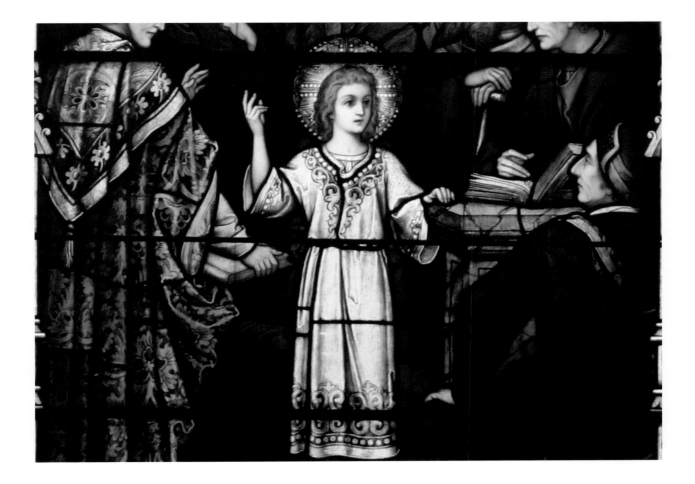

The finding of the child Jesus in the temple.

ST. IGNATIUS OF LOYOLA MAKING HIS VOWS.
A Spanish Basque priest, he founded the Jesuit Order; died in Rome in 1556 at the age of sixty-five.

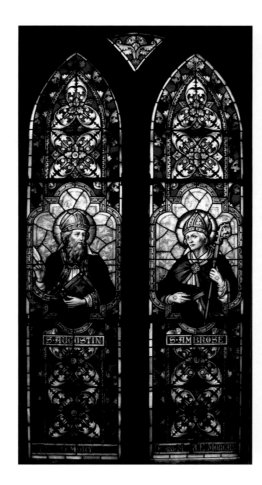
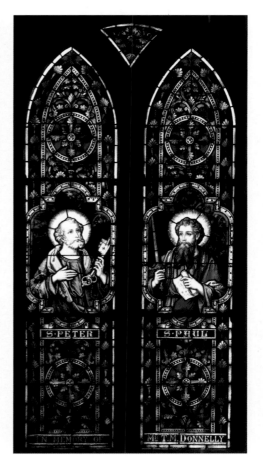

134

LEFT: ST. AUGUSTINE
Bishop of Hippo and Doctor of the Church, his classical autobiography is called *Confessions*. He died in AD 430 at the age of seventy-six.
RIGHT: ST. AMBROSE
Bishop of Milan, he was named a Doctor of the Church; died in AD 397 at the age of sixty-three.

LEFT: ST. PETER
The Apostle whom the Lord Jesus made the chief shepherd of His flock was crucified in Rome in AD 67. Two New Testament books are attributed to him.
RIGHT: ST. PAUL
Called by Christ to be Apostle of the Gentiles, he was beheaded in Rome in AD 67; thirteen New Testament books are attributed to him.

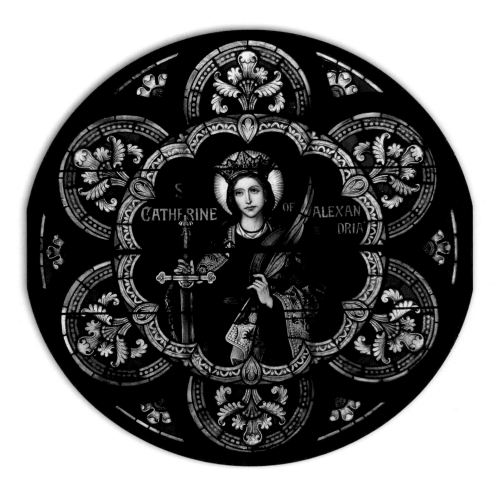

ST. CATHERINE OF ALEXANDRIA
An Egyptian who was martyred at age eighteen, ca. AD 250, she was buried miraculously on Mt. Sinai.

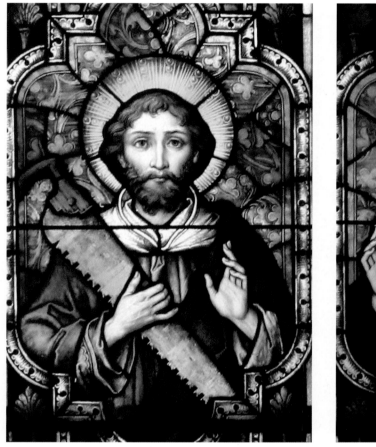

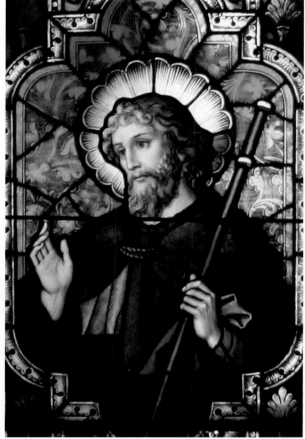

ST. SIMON
An Apostle whom the gospel calls a Zealot, he was
martyred in Persia by being sawed to death.

ST. JAMES MAJOR
Also called St. James the Greater, he was the first Apostle
to suffer martyrdom in Jerusalem.

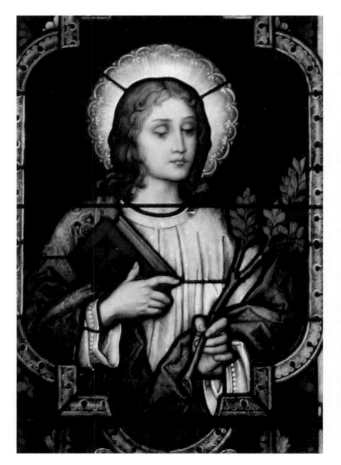 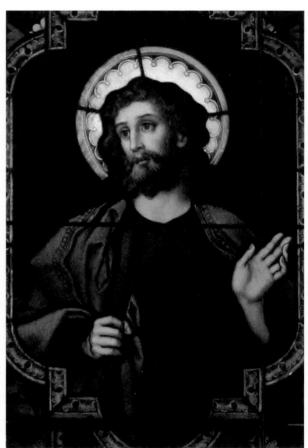

ST. JAMES MINOR

Also called St. James the Lesser, he was named the first Bishop of Jerusalem and one New Testament book is named after him. He was martyred in Jerusalem ca. AD 68.

ST. THADDEUS

An Apostle, often confused with Judas because his name was St. Jude Thaddeus, he has a New Testament book attributed to him.

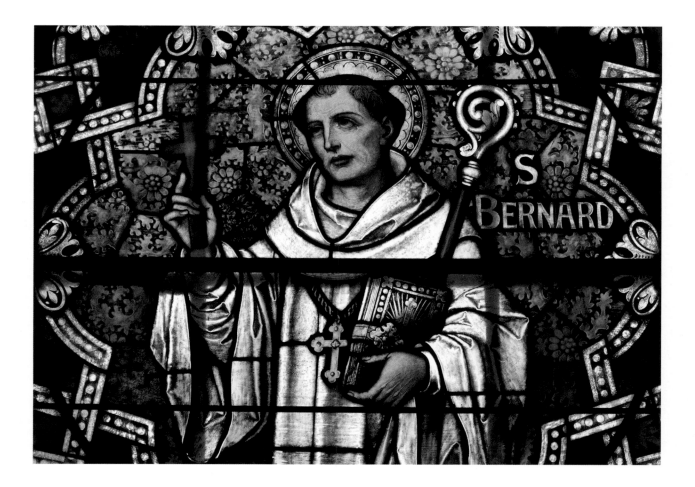

ST. BERNARD OF CLAIRVAUX
A great French monk, he founded the Trappist Order and is a Doctor of the Church; died in 1153 at the age of sixty-three.

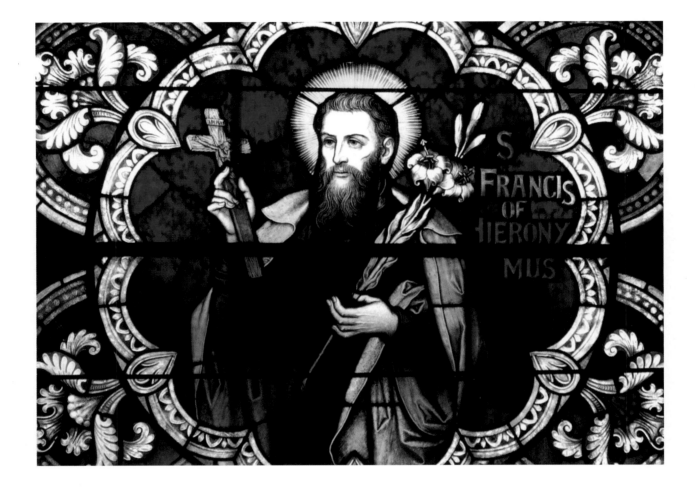

139

ST. FRANCIS (HIERONYMUS) DI GIROLAMO
An Italian Jesuit priest, he died in 1716 at the age of seventy-four in Naples.

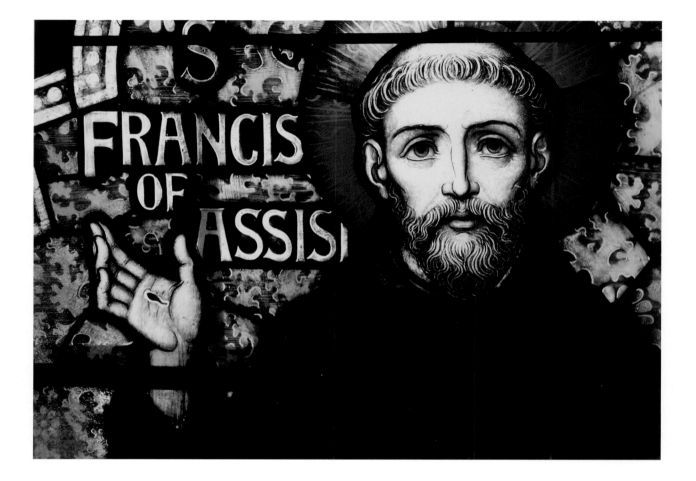

ST. FRANCIS OF ASSISI
An Italian who founded the Franciscan Order, he is remembered for his love of nature and animals. He received the stigmata and died in 1226 at the age of forty-five.

ST. URSULA
Daughter of a Christian British King, she was martyred with other virgins in Cologne, Germany, by the Huns, ca. AD 400.

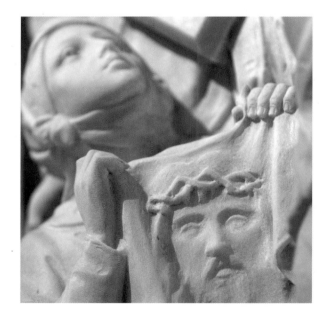

THE STATIONS OF THE CROSS

Katherine T. Brown, Ph.D.

Also called the Way of the Cross (*Via Crucis* in Latin) or the Way of Sorrows (*Via Dolorosa* in Latin), the Stations of the Cross are among the most popular Catholic devotions. In general, the Stations of the Cross are a series of fourteen "stops," each representing an event during Christ's Passion in Jerusalem, or more specifically, his journey from his condemnation at Pilate's House to the place of his Crufixion at Calvary. Each station is indicated by a wooden cross—usually marked with a Roman numeral— and most often, but not always, accompanied by an image that illustrates a particular scene. The images can be painted, sculpted, made in mosaic, engraved or printed, for example. The phrase "Stations of the Cross" can also refer to a specific devotion associated with the Passion; that is, worshipers need not be directly in front of works of art in order to pray the Stations of the Cross. The objective is to help the worshiper make a pilgrimage through the journey of Christ's sufferings by means of prayer and meditation.

THE 14 STATIONS OF THE CROSS ARE:

I.	Jesus is Condemned to Die.
II.	Jesus Carries His Cross.
III.	Jesus Falls the First Time.
IV.	Jesus Meets His Mother.
V.	Simon Helps Jesus Carry His Cross.
VI.	Veronica Wipes Jesus' Face.
VII.	Jesus Falls the Second Time.
VIII.	Jesus Meets the Women of Jerusalem.
IX.	Jesus Falls the Third Time.
X.	Jesus is Stripped.
XI.	Jesus is Nailed on the Cross.
XII.	Jesus Dies on the Cross.
XIII.	Jesus is Taken Down From the Cross.
XIV.	Jesus is Laid in the Tomb.

History and Origins

The precise origin of the Stations of the Cross is not known. Tradition asserts that the Virgin Mary visited the spots of her Son's Passion after his death, and Saint Jerome wrote that pilgrims from many countries came to visit these sites in his day (late fourth–early fifth centuries), although there is no specific evidence on either account. A desire to identify exact physical locations associated with the events of Christ's final hours was expressed by Saint Helena, mother of the Roman Emperor Constantine, who visited the Holy Lands in the fourth century for this purpose. We do know that many early Christians made pilgrimages to Jerusalem in order to visit these sites, for which an indulgence was granted. In fact, those Christians who were too poor, physically unable, or otherwise hindered from making the journey to Jerusalem wanted to be able to "visit" these sites spiritually. Hence, early artistic renditions of the Stations of the Cross were most likely made to aid those worshipers outside Jerusalem (and especially those in Europe) who could not make the actual journey. Some of the earliest Stations of the Cross were erected in Cordova (Spain), Messina (Italy), as well as Görlitz and Nuremburg (Germany).

The Franciscans, who were named guardians of holy sites in Jerusalem in 1342, are most likely the forefathers of the Stations of the Cross as we know them. During times when Muslim occupation of the Holy Lands made Christian pilgrimages difficult or perilous, Stations were placed inside churches as a safe alternative for making Jerusalem accessible to the masses. The earliest use of the word "Stations" in reference to stopping places on the road in Jerusalem can be found in the diary of an English pilgrim, William Wey, who visited the Holy Lands twice, in 1458 and later in 1462, and who wrote about following the footsteps of Christ during His last day. In 1505, Peter Sterchx of Flanders published a guide book called *Cruysgang* (*Way of the Cross*) that is most similar to the Stations we know today. By the sixteenth century, a tradition of beginning at Pilate's House and ending at Calvary had evolved as a devotional exercise, but it was not until the end of the seventeenth century that the erection of Stations of the Cross became relatively common.

Throughout these developments, the number and subjects of the Stations varied. In different accounts, the number of Stations has been 37, 31, 25, 19, and 12. Pope Clement XII in 1731 fixed the official number at 14, a number re-confirmed by Pope Benedict

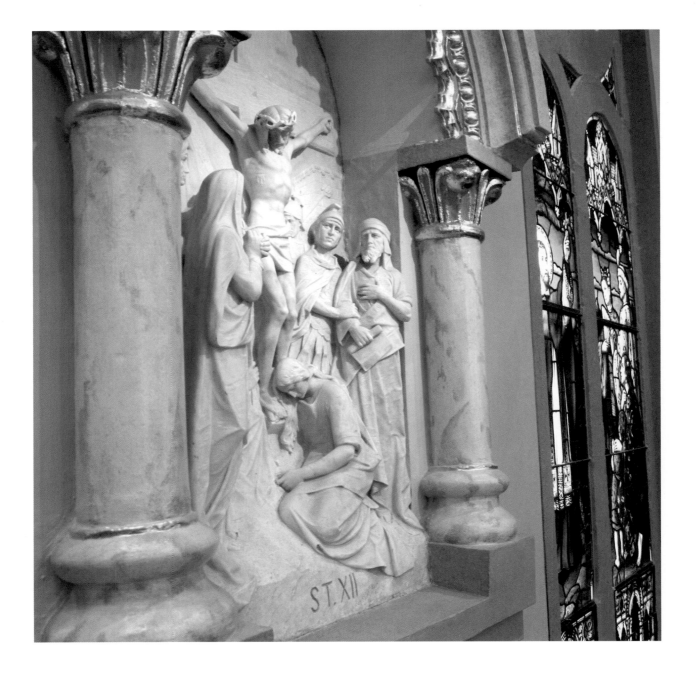

XIV in 1742. Today fourteen is the most common number of Stations. The variance may be attributed to the fact that some of the events in the Stations come directly from Scripture, and others are apocryphal. The appearance of Veronica, for example, whose name derives from vera icone, or "true image," is traditional. And the discussion is still on-going. In 1991, Pope John Paul II created a version of the Stations of the Cross in which all events were taken from Scripture and includes scenes, for example, of Peter's Denial of Christ, and excludes others, such as the Veronica story. Some Catholics today also advocate for the addition of a fifteenth Station, commemorating the Resurrection.

Practice

The practice of praying the Stations of the Cross is most frequent in the Roman Catholic Church, but forms also exist in the Anglican and Lutheran churches. The Stations may be a form of prayer and devotion at any time in the liturgical year; however, clergy place an emphasis on praying the Stations during the Season of Lent, especially on Good Friday and on Fridays during Lent. Stations can be located outdoors, especially in rural areas alongside roads that lead to a Church or shrine, but they are usually arranged around the walls

of the nave of a Church at regular intervals. Within the Church setting, the Stations typically begin on the Gospel side and wrap around the interior, encouraging the worshiper to move physically from one Station to the next. Ideally, the practice of praying the Stations should be uninterrupted and include a separate meditation on each of the fourteen events. In public devotion, typical musical accompaniment is the *Stabat Mater Dolorosa*, sung while moving from one Station to the next, with the *Adoremus Te* sung at the end of each Station.

THE STATIONS IN ST. JOSEPH CATHOLIC CHURCH

In regard to the series of Stations in St. Joseph Catholic Church, Italian artisans hand-carved the scenes from Carrara marble, perhaps the finest marble (meaning, with the fewest naturally occurring flaws) available anywhere in the world. All of the sculpture for the Stations was cut, finished, and crated in Italy before being shipped to Macon at the turn of the twentieth century. The Stations were installed within a few years after the interior construction, and were anchored to the brickwork. Although the names of the artisans remain unknown, each of the sculptors skillfully and naturalistically rendered the events in high relief. The translucent, soft gray marble is well suited for portraying a plethora of textures, from the rough tree bark, to smooth skin, to the shiny metal of the Roman soldiers' armor. The Sacred Heart Church in Augusta, also constructed by Brother Otten, S.J., has the same images for the Stations of the Cross, but the Augusta set is made in plaster rather than marble.

STATION I: Jesus is Condemned to Die.

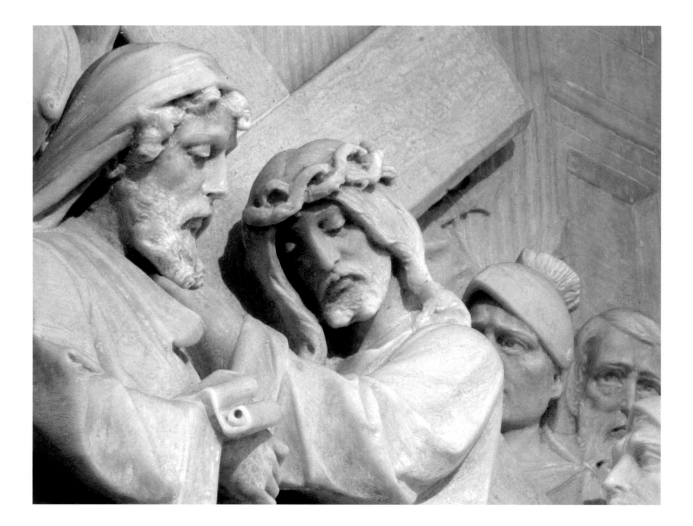

STATION II: Jesus Carries His Cross.

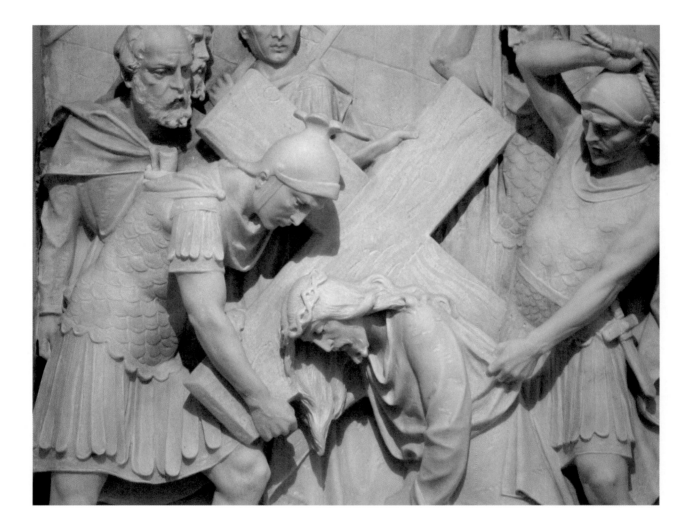

STATION III: Jesus Falls the First Time.

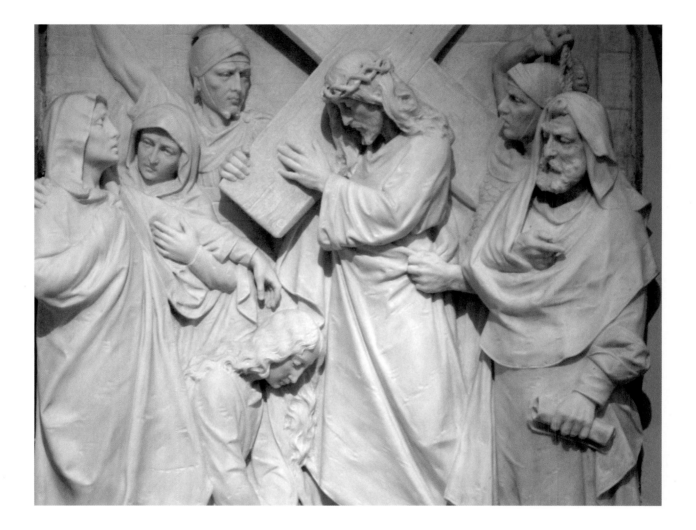

STATION IV: Jesus Meets His Mother.

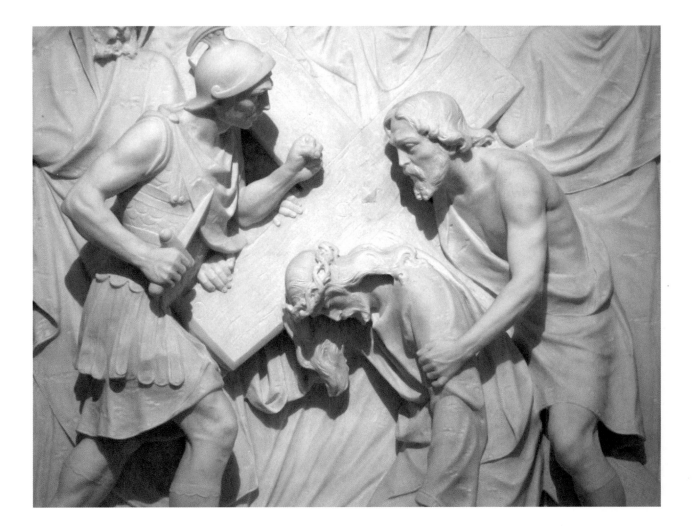

STATION V: Simon Helps Jesus Carry His Cross.

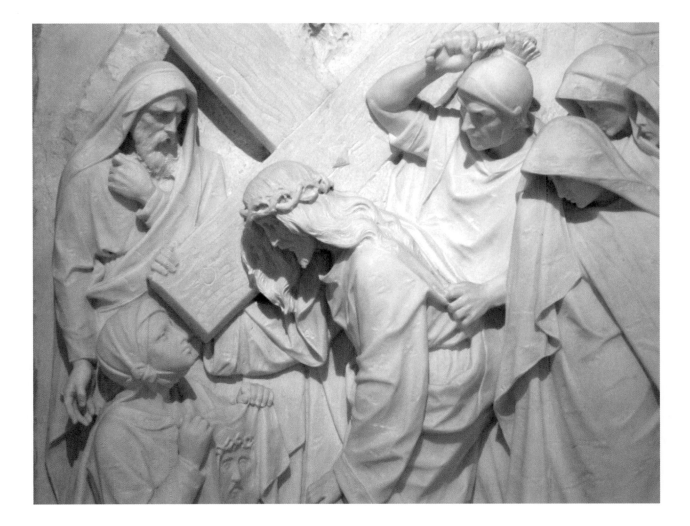

STATION VI: Veronica Wipes Jesus' Face.

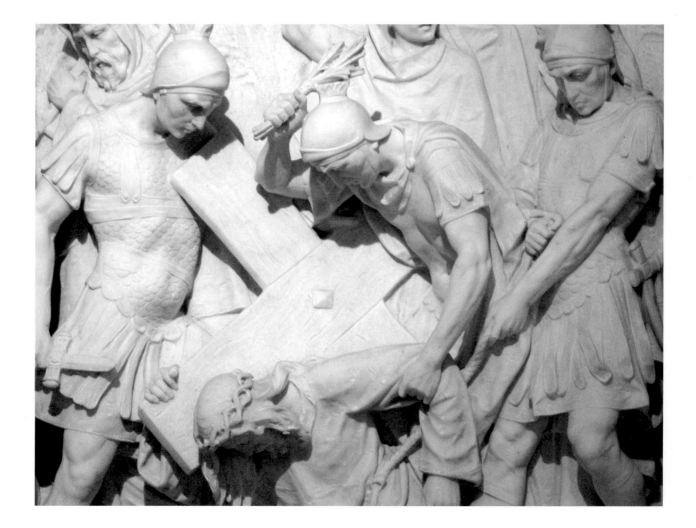

STATION VII: Jesus Falls the Second Time.

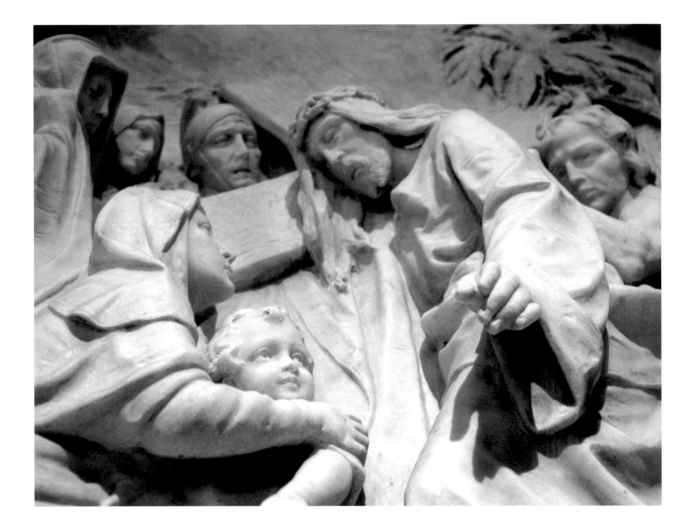

STATION VIII: Jesus Meets the Women of Jerusalem.

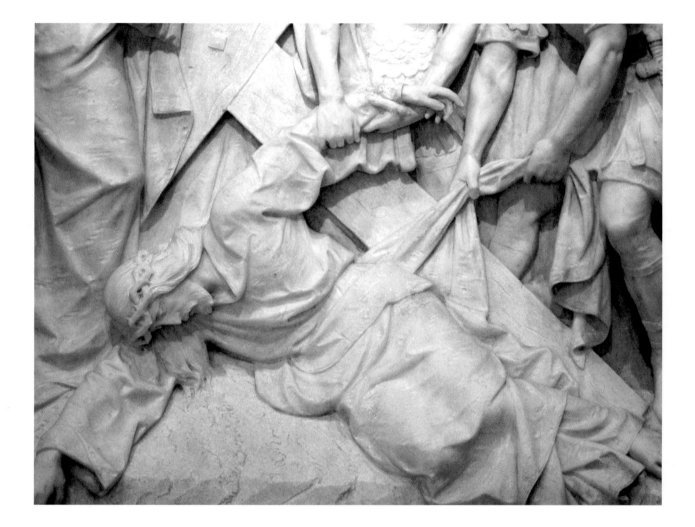

STATION IX: Jesus Falls the Third Time.

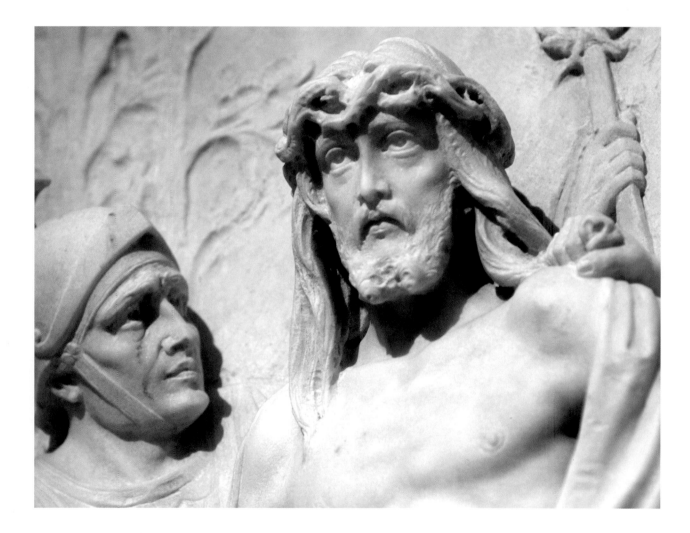

157

STATION X: Jesus is Stripped.

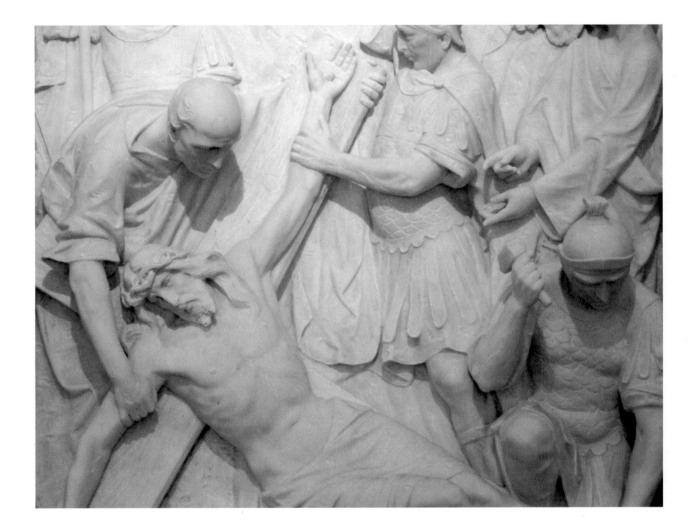

STATION XI: Jesus is Nailed on the Cross.

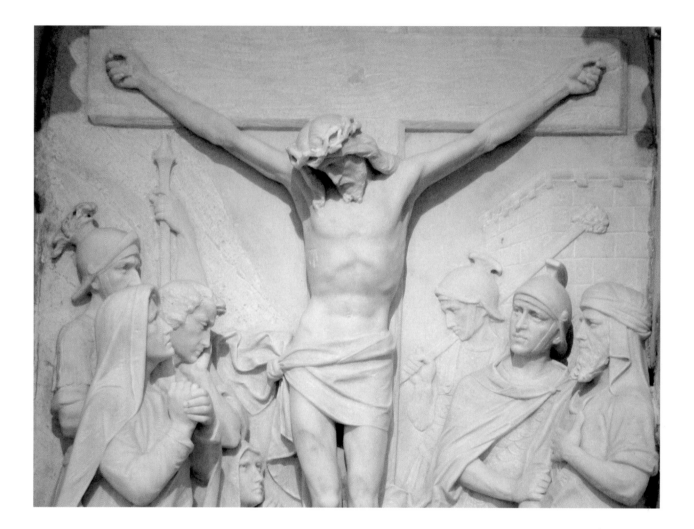

STATION XII: Jesus Dies on the Cross.

160

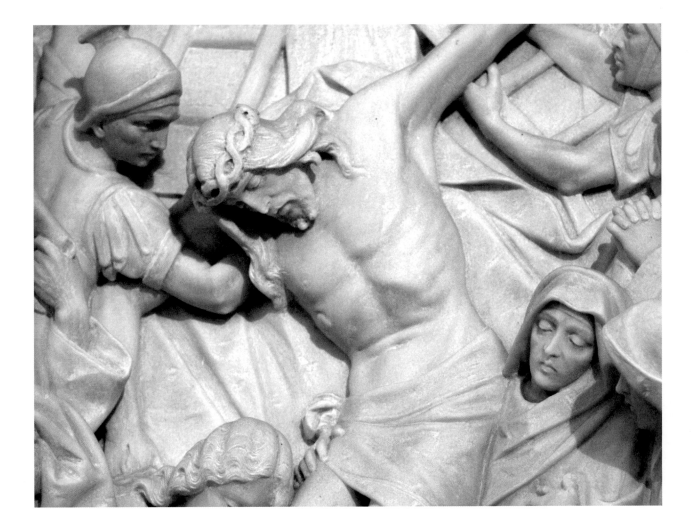

STATION XIII: Jesus is Taken Down From the Cross.

STATION XIV: Jesus is Laid in the Tomb.

STATUARY

Katherine Hutto and Joni Woolf

Most of the statuary in St. Joseph Catholic Church is sculpted from the same Carrara marble as the altars. Seen as a means of bringing parishioners closer to God, worshipers are led to meditate on the works of the saints who have gone before. Though the names of the sculptors are unknown, their art continues to inspire worshippers to a devout and obedient life. We are called to examine our lives as we reflect on theirs.

As your back is to the Altar and you are looking at the main doors that exit to Poplar Street, the statue of St. Ignatius of Loyola is on the left (closest to Station of the Cross VIII) and as you move to the right you will see statues of St. Vincent de Paul, St. Anthony of Padua, and then St. Therese of Lisieux (nearest Station of the Cross VII).

St. Ignatius of Loyola founded the Society of Jesus whose members are called Jesuits. Jesuit priests played a very important role in early Catholicism and in establishing and administering our Catholic churches in Macon. Born to Spanish nobility in 1491, St. Ignatius of Loyola was the youngest of twelve children. He wrote *Spiritual Exercises* which describes a series of meditations to be followed by those who came to him for spiritual direction. Under his leadership, numerous schools, colleges, and seminaries were established by the Jesuits.

St. Vincent de Paul was born in 1581 to a peasant family in southwest France. He was best known for his charitable work in helping the poor, needy, and abandoned; he nursed the sick and he helped the unemployed find work. St. Vincent de Paul also helped found the Sisters of Charity.

St. Anthony of Padua (nee Ferdinand Bouillon) was born to a wealthy family in 1195 in Lisbon, Portugal. He became a Franciscan priest before entering the Order of the Friars Minor. St. Anthony was extremely knowledgeable about theology and scripture and was known as a gifted speaker in many languages.

St. Therese of Lisieux, also known as Therese of the Child Jesus or the Little Flower of Jesus, was born in 1873 to a middle-class French family. She was cured from a serious illness at age eight when a statue of the Blessed Virgin Mary smiled at her. At age fifteen, St. Therese became a Carmelite nun. Her autobiography, *Story of the Soul*, is well-known, and many miracles have been attributed

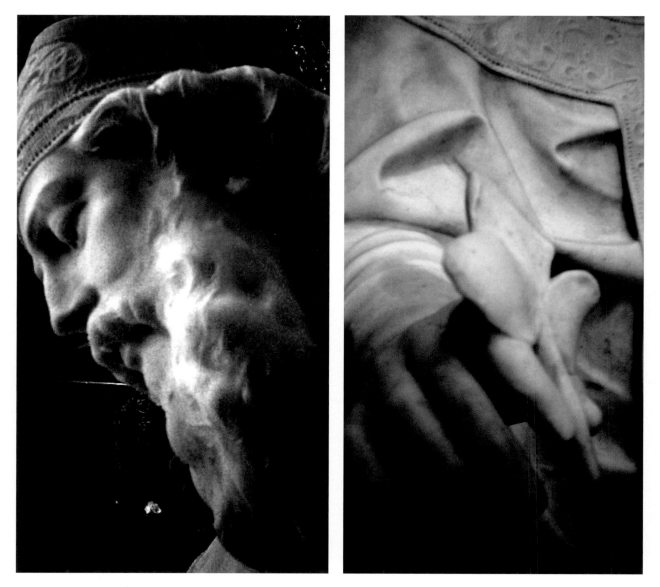

At left is the face of St. Patrick. At right, he holds a shamrock in his hand, signifying the Holy Trinity—Three, yet One.

to her works. St Therese practiced the virtues of what is called the "Little Way" in which one makes love of, and trust in, God the center of one's life. A rose, or a symbol of a rose, is often considered St. Therese's sign that God has heard one's prayers.

St. Patrick was born in Scotland in AD 387, carried off into captivity by Irish marauders and sold as a slave when he was sixteen. During six years of captivity, he learned to pray and prepared himself for his lifelong work. He studied and was ordained to the priesthood under St. Germanus, Bishop of Auxerre. Pope St. Celestine I entrusted Patrick with the mission of gathering the Irish race into the fold of Christ, and upon his return to Ireland, he worked many miracles, leading people to the faith. On one occasion, he is said to have plucked a shamrock to explain by its triple leaf and single stem the great doctrine of the Holy Trinity. During the Dark Ages the monasteries of Ireland were the great repositories of learning in Europe, all a consequence of St. Patrick's ministry.

St. Michael, Archangel, whose feast day is September 29, is patron saint of grocers, mariners, paratroopers, police, and sickness. The name Michael signifies "Who is like to God" and was the war cry of the good angels in the battle fought in heaven against Satan and his followers. Holy Scripture describes St. Michael as "one of the chief princes," and leader of the forces of heaven in their triumph over the powers of hell. He has been especially honored and invoked as patron and protector by the Church from the time of the Apostles.

St. Gabriel, Archangel, appears four times in Scripture. On three of those occasions he is foretelling the coming of a great event: the coming of the Messiah, the birth of John the Baptist, and the birth of the Messiah to the Blessed Virgin Mary. Thus we see Gabriel as the bearer of good tidings and as the comforter and helper of men. Christian tradition holds that Gabriel is the unnamed angel who spoke to St. Joseph and proclaimed the birth of Christ to the shepherds. He is also believed to be the angel who comforted Jesus in the Garden of Gethsemane. His feast day is September 29, a day he shares, since Vatican II, with St. Michael and St. Raphael.

The Church's altars are described in detail in the first chapter of this book, thanks in large part to the words of Sister Mary Sheridan in *History of Saint Joseph's Parish, Macon*, 2001. The altars are of primary importance to Catholics—central to faith and practice—for this is the place where priests and parishioners experience the celebration of the

Holy Eucharist. Consider the detail in the High Altar, the Blessed Mother Altar, and the Sacred Heart Altar. Meditate on the works of marble that human hands created, seeking expression of the inexpressible. Come apart from the world for a time. In the quiet of this holy place—created by mortals in search of the divine—find the peace that passes understanding, the peace of God.

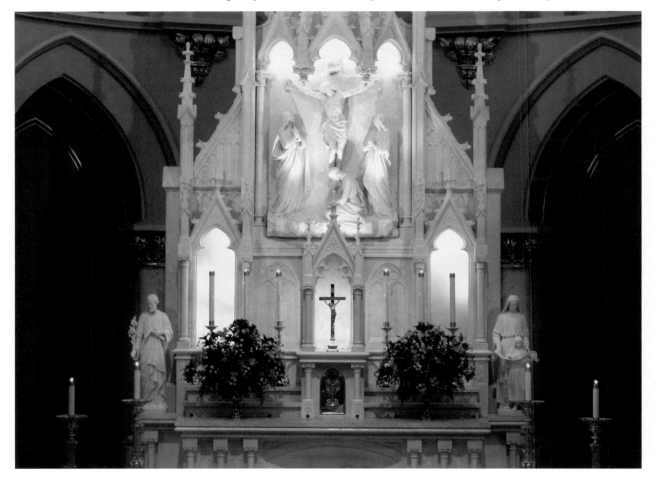

The High Altar, installed in 1918, still enthralls all who look upon it.

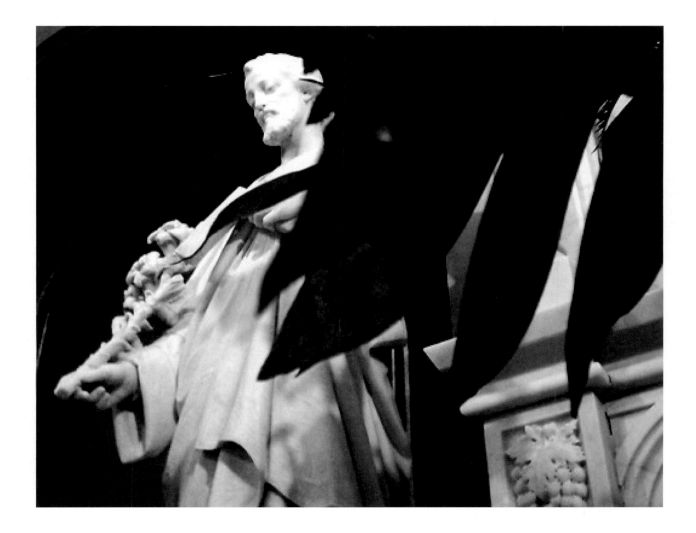

St. Joseph, patron saint of St. Joseph Catholic Church, stands on the left side of the High Altar.

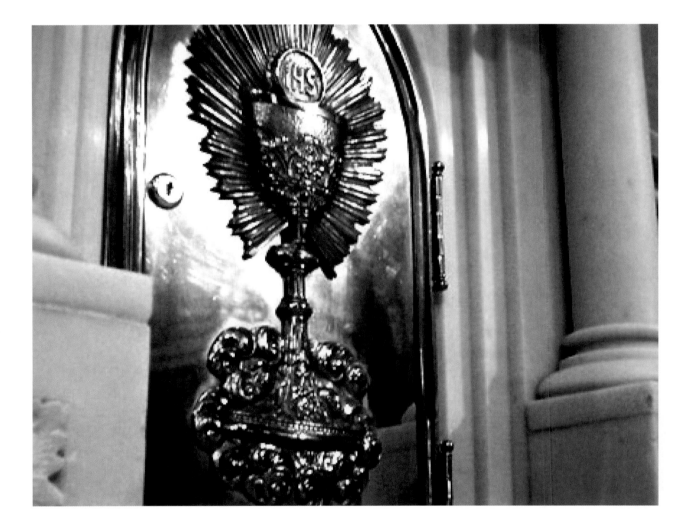

The High Altar Tabernacle.

St. Therese of Lisieux

St. Anthony of Padua

St. Vincent de Paul St. Ignatius of Loyala

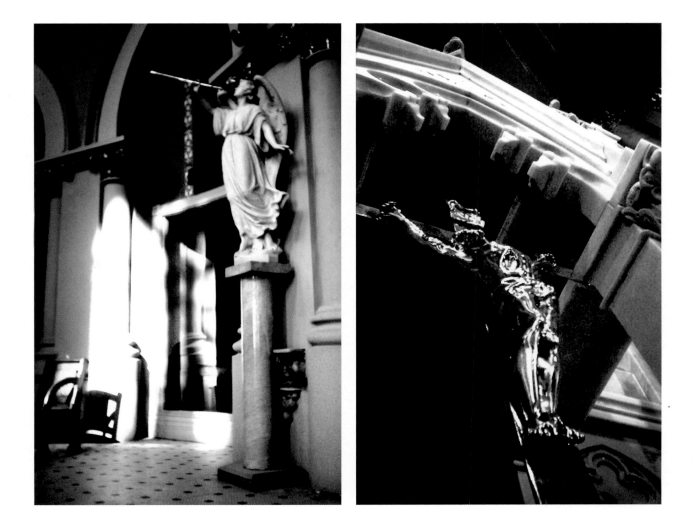

Left: High on a pedestal, St. Gabriel appears as the bearer of good news. Right: A dramatic view of the crucifix that is in the center of the reredos.

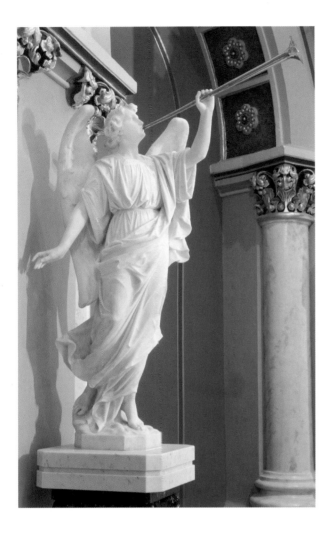

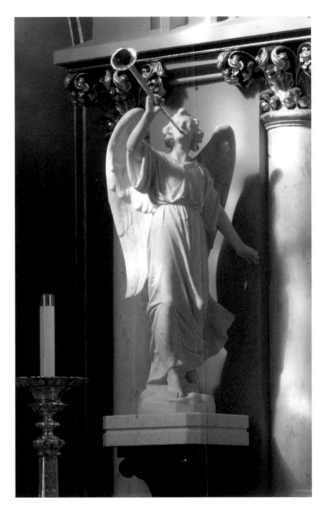

St. Michael, Archangel

St. Gabriel, Archangel

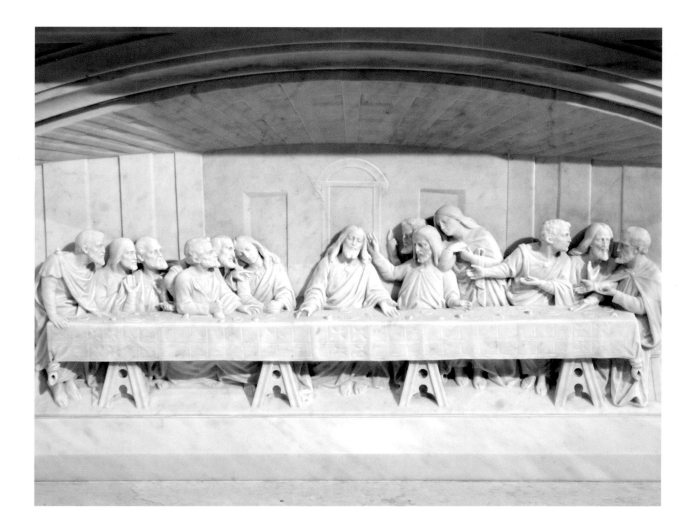

The Last Supper, based on Leonardo Da Vinci's famous mural, is carved into the marble at the base of the High Altar.

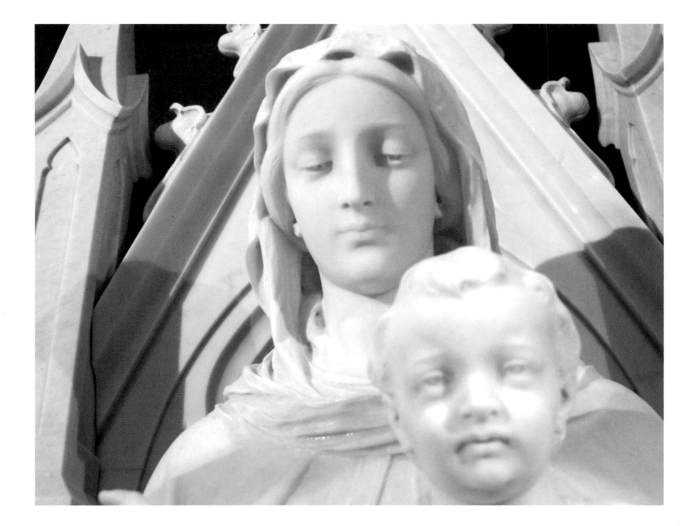

To the right of the High Altar is the Altar of the Blessed Mother.

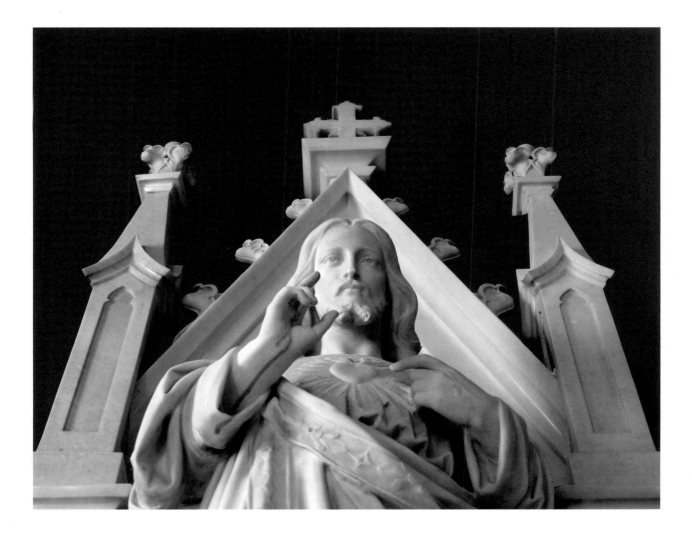

To the left of the High Altar is the Altar of the Sacred Heart.

Detail of the Archangel St. Gabriel.

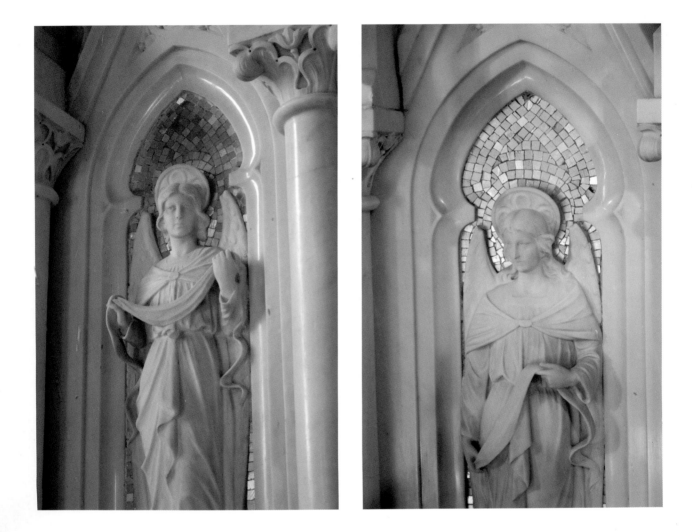

These angels appear at either side of the Blessed Mother Altar.

17≝

OBSERVATIONS AND REFLECTIONS

Chris R. Sheridan Jr.

The overwhelming observation that filled us all at the time of the work, and with 20/20 hindsight, is how fortunate we all were for the chance to work on such a project. It truly was a once in a lifetime opportunity, and everyone involved realized that and became infected with the wonder of the situation. One of the best examples of this was found in the following note when we did the final punch list. The area where it was found cannot be accessed unless you build a scaffold tower eighty-seven feet above the floor of the Church, a task that most likely will not be done for at least another hundred years. Then, only when someone erects that scaffold and crawls through an eighteen inch square opening will they be able to see the note on the back of a wall. But one day someone will, and they will see this voice from the past:

I, Bill Amann, employed with Chris Sheridan & Co. for 20 years had the honor of helping in the 100-year restoration of this church.

We removed all the stained glass windows. I replaced the Rose window and 80% of all windows in the upper level, cut holes and mounted 80% of ceiling lights. I helped in building the scaffolding to reach from the floor up to different levels and finally up to the cupola.

I started on this job in February 2004 and I'm still here working 3-01-05 while others left. This is one beautiful church and many people are in awe of the work all of us have done. I'm proud to have been part of it.

See you in the future!

God Bless You, WRA

Often during quiet moments in the Church alone, I would catch myself full of the feelings of family and tradition and how it came together

Germany, did such fine and detailed work, and paid such close attention to every square inch of the over 662,400 square inches of exquisite stained glass. This glass is remarkable first for its cohesive design theme. It is rare in a Church that one finds each and every window's theme and location so carefully considered. It is not uncommon to find multiple suppliers of windows in a given Church, but in St. Joseph Church almost all of the original windows are from a single supplier. Furthermore, each one was carefully designed with its final location in mind. Take the nave, for example: The first windows, starting from the rear, are pairs of saints. They are paired based on Jesuit history, and the color schemes match the windows across the Church. The last window in the nave toward the altar, on one side, is St. Francis Xavier preaching to the Japanese, while across from it is St. Patrick preaching to the Irish. The color schemes of the Doctors of the Church in the upper transept, likewise, match what is across the Church. At every turn one can find care and thought given to the smallest of details to make for a cohesive design.

The tradition and skill of the sculptors of Cararra, Italy, who hand-carved the Stations of the Cross, are evident. Get very close to these Stations. The

181

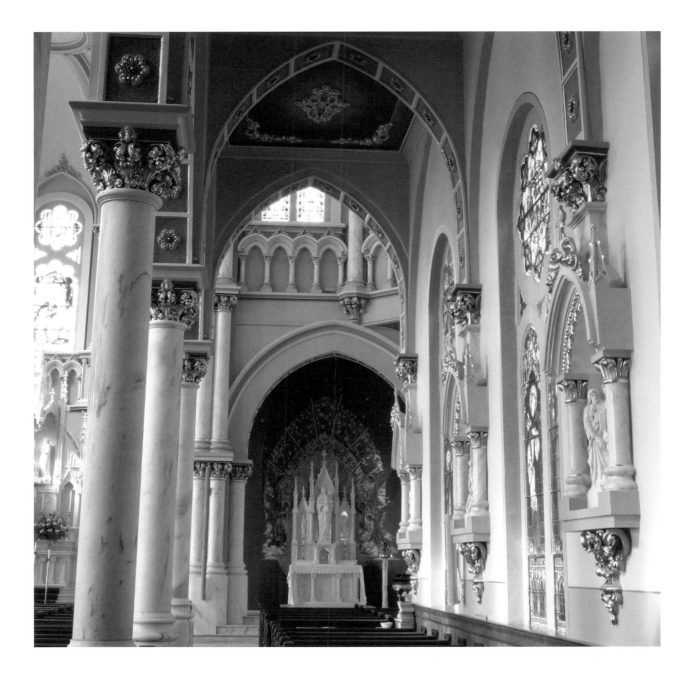

level of detail is astonishing. Look at the fingers and toes and veins in the straining bodies and realize the effort to carve the stone away to reveal such a spirit. What a gift these sculptors gave us!

The tradition and skill of the brick masons who built the shell of the Church amaze anyone who ever laid a brick. Pay particular attention to the round columns at the base of each flying buttress. The brick is laid in a sawtooth fashion, a very difficult technique to do well in a straight wall but exceptionally difficult to do in a round column. Every brick is laid perfectly.

But the tradition and skill I thought about the most was that of the many blue-collar immigrants who sacrificed so much to build our Church in the first place. What kind of faith compels a group of people to give so much? A much lesser Church certainly would have still been considered grand. In addition to being the supervising architect on three other Churches, Brother Cornelius Otten, S.J., supervised the construction of St. Joseph Church. All along the way each congregation makes choices about the level of finishes in a Church. Compared to the other three "Brother Otten" Churches, St. Joseph's is the finest. It has marble floors compared to terrazzo or other lesser quality material in the others. Almost all the windows are Mayer windows compared to various suppliers in the others. The Stations of the Cross are hand-carved Cararra marble, compared to plaster castings in the others. The families that built St. Joseph's were not wealthy, but they were very rich in faith. To sit alone in that Church, on a scaffold high in the air during renovation or in a pew today, to see the sun move across the sky by way of the light on the walls, and to think about all the faith and resources it took to make this Church happen, is a soulful experience that truly brings one closer to God.

RESIDENT PASTORS

Church of the Assumption

Rev. James Graham	1841-1842
Rev. Thomas Murphy	1843-1845
Rev. Jeremiah J. O'Connell	1845-1846
Note: Priests were supplied monthly from Savannah from Sept. 1846 until Jan. 1849	
Rev. Thomas F. Shanahan	1849-1850
Rev. Edward Quigley	1850-1853
Rev. J. H. O'Neill	1854-1856
Rev. James Hassan	1856-1859
Rev. Thomas O'Reilly	1859-1861
Rev. Michael Cullinan	1861-1863
Rev. William Hamilton	1864-1866
Rev. J. F. O'Neill Jr.	1866-1868
Rev. Louis Dennis Xavier Bazin	1868-1882

St. Joseph Catholic Church

Rev. J. F. Colbert	1883-1885
Rev. Godridus Schadewell	1885-1887
Rev. John B. Quinlan, S.J.	1887-1889; 1892-1894
Rev. Joseph Winkelried, S.J.	1889-1892; 1894-1907
Rev. Thomas D. Madden, S.J.	1907-1913; 1923-1928
Rev. Joseph B. Franckhauser, S.J.	1913-1919
Rev. W. A. Wilkinson, S.J.	1919-1923
Rev. Felix J. Clarkson, S.J.	1928-1935
Rev. Peter McDonnell, S.J.	1935-1941
Rev. Harold A. Gaudin, S.J.	1942-1946
Rev. Robert T. Bryant, S.J.	1946-1952
Rev. Carmine Benanti, S.J.	1953-1958
Rt. Rev. Msgr. Thomas I. Sheehan	1959-1968
Rt. Rev. Msgr. John D. Toomey	1968-1969
Rev. William V. Coleman, V.F.*	1970-1974
Rt. Rev. Msgr. John Cuddy, V.F.*	1974-2004
Rev. Allan McDonald	2004-present

*V.F.= Vicar Forane = Dean of Macon Deanery

ST. JOSEPH'S ORGANISTS

Professor J. G. Weisz (organist for more than sixty years)
Mrs. Celia Weisz Giglio (Professor Weisz's daughter)
Mrs. Blandina Winkers
Mr. Ernie Dalton
Mr. John O'Steen
Dr. Fletcher Anderson
Ms. Nelda Chapman

FOUNDING FAMILIES: (AS NOTED ON TWO PLAQUES BY THE MAIN ENTRANCE/VESTIBULE)

Ancient Order of Hibernians
(Members of)
Baker, Mrs. V. G.
Brennan, Mr. T.
Burke, Mr. & Mrs. Christopher
Burke, Mr. & Mrs. T. C. & family
Butler, Rev. T. W. , S.J.
Callaghan, Mr. & Mrs. Martin
Campbell, Mr. & Mrs. John
Carling, Mr. & Mrs. Thomas J. & family
Cassidy, Mr. & Mrs. Dennis & family
Cassidy, Mr. & Mrs. Edward
Cassidy, Mr. & Mrs. James
Cassidy, Mr. & Mrs. John
Cassidy, Mr. & Mrs. Michael
Cassidy, Mr. Owen
Cassidy, Mr. & Mrs. Patrick
Cassidy, Mr. & Mrs. S. Edw.
Cassidy, Mr. & Mrs. S. James
Coffey, Mr. & Mrs. D.
Coffey, Mr. & Mrs. J.T.
Condon, Mr. Larry
Crimmins, Mr. & Mrs. Jer. C. & family
Daly, Prof.& Mrs. F.J. M.
Daly, Mr. Henry F.
Daly, Mr. & Mrs. Ignatius
Daly, Mr. & Mrs. Matthew & family
Daly, Mr. & Mrs. Michael & family
Dempsey, Mrs. Lillian
Dempsey, Mrs. Maria
Dempsey, Miss Marie
Dempsey, Mr. Thos.
Devlin, Mr. John Patrick
Donahue, Mr. & Mrs. John H.
Donahue, Mr. & Mrs. Tim
Donnelly, Mr. & Mrs. T. M.
Doody, Mr.W.A.
Doody, Mr. & Mrs. W.A. & family
Dorr, Mr. & Mrs. Aug. M. & family
Doyle, Mr. & Mrs. Patrick & family
Fabacher, Mr. & Mrs. L. & family
Fagan, Mr. Thos.
Fern, Mr. Dugal & family
Fern, Mr. & Mrs. M. & family
Fitzgerald, Mr. & Mrs. M.
Flahive, Mr. & Mrs. J.J. & family

Flynn, Misses B. & E. & Parents
Foley, Mr John
Foley, Mrs. Margaret
Foley, Mr. & Mrs. Theo M. & family
Franke, Mr. & Mrs. J.E. J. & family
Gallagher, Mr. & Mrs. E.M.
Gildea, Messrs. Dennis & Patrick
Grace, Mr. & Mrs. Lee W.
Grahan, Mr. & Mrs. John
Greene, Mr. Geo. & Miss Josephine
Harvey, Mr. E. I.
Harvey, Mr. & Mrs. James & family
Hayes, Mr. & Mrs. John J. & family
Horne, Mr. & Mrs. E. A. & family
Horne, Mr. & Mrs. H. & family
Horne, Mr. Henry
Hornsby, Mr. & Mrs. Phalba E. & family
Hornsby, Mr. & Mrs. S.P. & family
Hurley, Mr. & Mrs. JNO & family
Irish Historical Club
Jocoby, Mr.& Mrs. Anthony
K. of C. Macon Council 925
 (Knights of Columbus)
Keating, Mr. & Mrs. A. & family
Keating, Miss Lizzie
Kennington, Mr. & Mrs. F. & family
Lackay, Mr. John
Lyons, Mr. W. C.
MacMillan, Mr. & Mrs. J.O.
MacMillan, Mr. James
Madden, Rev. Thos. D., S.J.
Mallee, Mr. & Mrs. Patrick
Markwalter, Mr. & Mrs. F. H.
McCafferty, Mrs. P. & family
McDonnell, Mr. & Mrs. Bernard
 & family
McDonnell, Mr. C.
McDonnell, Mr. & Mrs. JNO & family
McDonnell, Rev. JNO. P., S.J.
McGill, Messrs. Felix & Arthur & family
McGloin, Mr. & Mrs. P. A.
McKay, Mr. & Mrs. W.
McKenna, Mr. & Mrs. A. & family
McPhillips, Mr. & Mrs. James & family
Morgan, Dr. James & Mrs. Norah
Muldowney, Mr. Chas. B.

Murphy, Mr. John
Murphy, Mr. & Mrs. Leslie & family
Murphy, Mr.& Mrs. Patrick & family
Murtheagh, Mr. & Mrs. P.
Needham, Mr. & Mrs. R. & family
Newcomb, Mr. & Mrs. J.A.
O'Connell, Mr.& Mrs. Edw. & family
O'Hara, Miss Ellen
O'Hara, Mr. & Mrs. Michael & family
O'Hara, Mr. & Mrs. Patrick A.& family
Otten, Bro. C., S.J.
Quinlan, Rev. JNO B., S.J.
Redmond, Mr. & Mrs. Michael Jr.
Redmond, Mr. & Mrs. Michael Sr.
Schatzman, Mr. & Mrs. W. L.
Schneider, Mr. & Mrs. Anthony
Schoeneman, Mr. & Mrs. F. & family
Sheehan, Mr. & Mrs. Dennis
Sheehan, Mr. Thad
Sheridan, Mr. & Mrs. Chris, Sr., & family
Sheridan, Mr. & Mrs. Robert & family
Sheridan, Mr. & Mr. Thos. F. & family
Slavin, Mr. Patrick
Springer, Mr. & Mrs. F. J. & family
Strang, Mr. & Mrs. W. B. & family
Strang, Mr. & Mrs. W. B. Jr. & family
Stuart, Mrs. Bridget
Sullivan, Dr. & Mrs. J.S.
Sullivan, Mr. C. & family
Sweeney, Messrs. Patrick & Miles
Thomas, Mr. James
Thomas, Mr. John
Valentino, Mr. & Mrs. John
Vannucci, Miss Aurelia
Waggenstein, Mr. Louis
Waggenstein, Mr. & Mrs. Robert
 & family
Ward, Miss E.A.
Ward, Mr. & Mrs. P.H.
Ward, Mr. & Mrs. Patrick
Weisz, Prof. & Mrs. J.G.
Wicks, Mrs. Frances A.
Wicks, Miss M. Teresa
Wilkinson, Mr. & Mrs. James
Winkelried, Mr. & Mrs. JNO J. & family
Winkelried, Rev. Jos. M., S. J.

STAINED GLASS WINDOWS

MAIN ENTRANCE

4 Christ with the Crown of Thorns	In Memory of Christopher Burke
4A Christ with Nicodemus	In Memory of Mr. & Mrs. John Valentino
5 The Last Supper	In Memory of my Parents, Gift of H. Horne
6 Our Lady of Sorrows	In Memory of Catharine Burke
6A Baptism of Christ in the Jordan	In Memory of W.A. Doody by his Sister

LOWEST LEVEL OF LEFT NAVE

9 St.Teresa and St. Bridget	Gift of Erin's Sons
9 (round) Crown of Victory & Palms	
10L St. Rose of Lima and l0R St. Agnes	Gift of Cassidy Brothers
10 (round) Holy Spirit	
11L St. Alphonse Liguori	Gift of Mr. & Mrs. M. O'Hara
11R St. Anthony of Padua	Gift of Mr. & Mrs. Ignatius Daly
11 (round) Holy Eucharist	
12 St. Patrick Preaching to the Irish People	In Memory of Mr. P. Doyle & Family
12 (round) Angel represents Gospel of St. Matthew; Lion represents Gospel of St. Mark	

LOWEST LEVEL OF SOUTHEAST TRANSEPT

13 John Leans on Christ at the Last Supper	In Memory of M.M. Fern
14 Christ Appears to Mary Magdalene	F. A. Schoeneman
15 Apparition of the Sacred Heart	Gift of Mr. T.C. Dempsey & Family
16 Jesus with the Children	Gift of Mr. John Lackay
17 Agony in the Garden of Gethsemane	In Memory of Leon Cusson

LOWEST LEVEL OF NORTHWEST TRANSEPT

18 Our Lady of Lourdes	Gift of M.J.W.
19 St. Anne Presenting Mary in the Temple	Gift of Mr. & Mrs. Thomas F. Sheridan
20 Assumption of B.V.M*	In Memory of Mr. & Mrs. A. McKenna
21 Blessed Mother Giving Rosary to St. Dominic	Gift of the Sodalities of B.V.M.
22 The Holy Family	Gift of Miss E. A. Ward

LOWEST LEVEL OF RIGHT NAVE

23L St. Francis Xavier Preaching to the Japanese	Gift of Mr. & Mrs. G.L. Blaess and Mr. T. C. Hanse
23 (round) Eagle represents Gospel of St. John Ox represents Gospel of St. Luke	
24L St. Aloysius	Gift of the Redmond Family
24R St. John: Berchmans	Gift of the M. Fitzgerald Family
24 (round) Lamb of God	

*Originally commissioned as the Assumption of the Blessed Virgin Mary, the window more nearly represents the doctrine of the Immaculate Conception, according to Biblical scholars.

STAINED GLASS WINDOWS

25L	St. Elizabeth	Gift of Mr. & Mrs. Matthew Daly
25R	St. Veronica	Gift of Mr. & Mrs. M. Callaghan
25	(round) Adoration of the Holy Eucharist	
26L	St. Peter Claver	Gift of Mrs. S. L. Taylor
26R	St. Vincent de Paul	Gift of the Dinkler Family
26	(round) Keys to the Kingdom	

CLERESTORY WINDOWS OF LEFT NAVE

33 St. Monica
34 St. Benedict
35 St. Peter Canisius
36 St. Francis de Sales

CLERESTORY WINDOWS OF SOUTHEAST TRANSEPT

37L	St. Thomas	Messrs. Flatwood & Klopper
37R	St. Mathias	Mr. & Mrs. J. M. Holloway
38L	St. Bartholomew and 38R St. Philip	The Yeager Family
39	St. Cecelia	
40L	St. John and 40R St. Andrew	Altar Society and League of the Sacred Heart
41	St. Gregory and St. Jerome	In Memory of Mr. Michael Daly

APSE OR SANCTUARY WINDOWS (Left to Right)

42	Our Lord Appears to St. Thomas	Mr. & Mrs. Thomas Carling
43	The Marriage of Mary and Joseph	Mr. George W. Greene
44	The Annunciation	Mr. & Mrs. T. C. Burke
45	The Death of St. Joseph	Gift of M. W.
46	The Nativity	Gift of the Horne Family
47	The Finding of the Child Jesus in the Temple	Gift of the John Hurley Family
48	St. Ignatius of Loyola Making His Vows	Gift of the Sheridan Family

CLERESTORY WINDOWS OF NORTHWEST TRANSEPT

49L	St. Augustine and 49R St. Ambrose	In memory of Dr. & Mrs. J.E. Morgan
50L	St. Peter and 50R St. Paul	In memory of Mr. T. M. Donnelly
51	St. Catherine of Alexandria	
52L	St. Simon and 52R St. James Major	Gift of Mr. & Mrs. A. Schneidern
53L	St. James Minor and 54R St. Thaddeus	Dr. & Mrs. Damour and Mrs. E. Damour

CLERESTORY WINDOWS OF RIGHT NAVE

54 St. Bernard
55 St. Francis of Girolamo (Hieronymus)
56 St. Francis of Assisi
57 St. Ursula

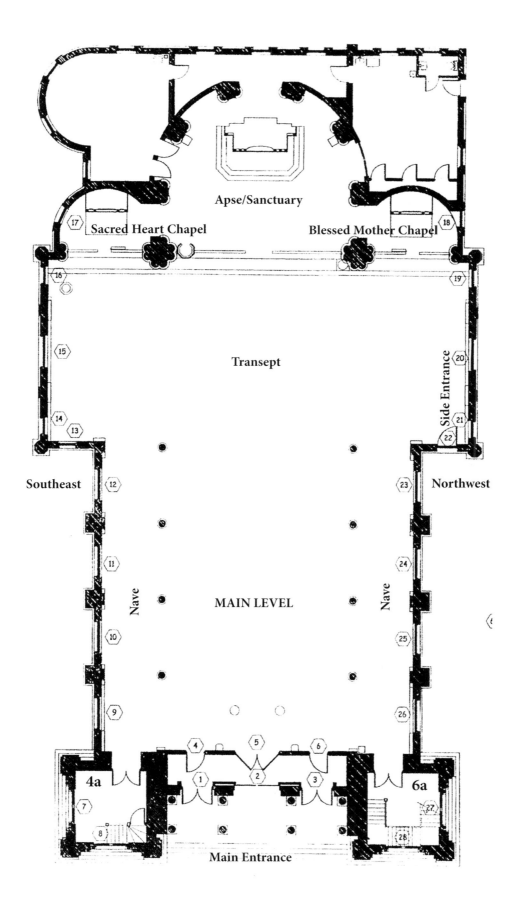

188

Apse/Sanctuary

Sacred Heart Chapel

Blessed Mother Chapel

Transept

Side Entrance

Southeast

Northwest

Nave

Nave

MAIN LEVEL

4a

6a

Main Entrance

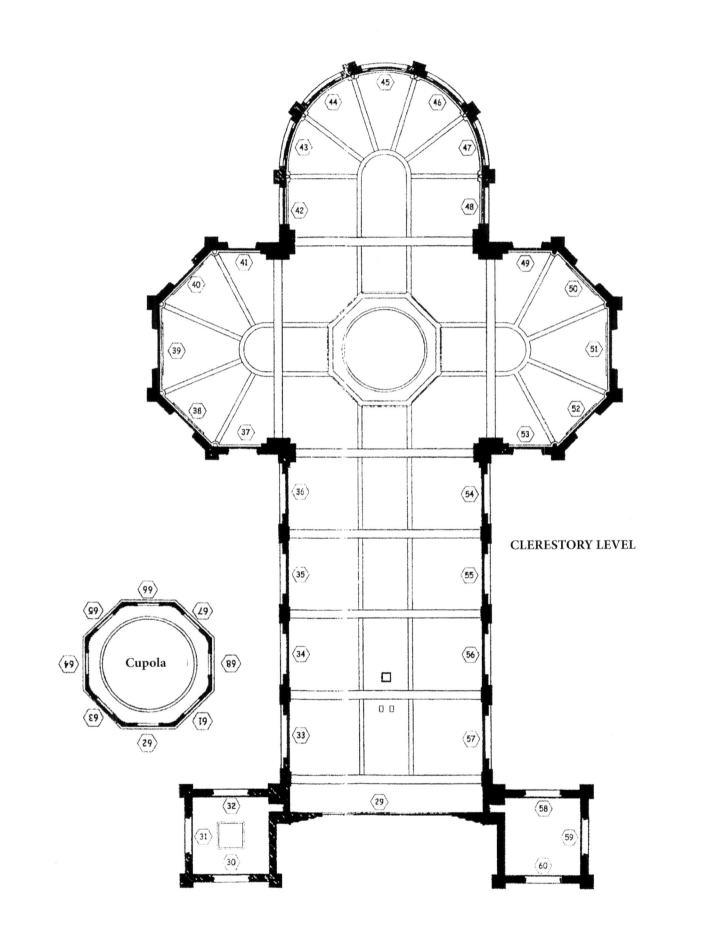

CLERESTORY LEVEL

Cupola

INDEX

A

Adoremus Te 147
Agony in the Garden
 of Gethsemane 104
Alexander, Elam 11
Amann, Bill 44, 179
Anglican Church 146
Annunciation 129
Apparition of the Sacred Heart 102
Assumption of B.V.M. 107
Augusta, Sacred Heart Church 147
A Touch of Glass Studios 43

B

Bates, Maryann 8, 43, 74, 75
Becker, Bishop Thomas 15
Benedetto 37
Bibb County 13
Blessed Mother Chapel
 and Altar 25, 30, 56, 71, 81,
 84, 85, 165, 173, 176
Blessed Mother 25, 108
Boland, Bishop J. Kevin 9, 27
Brief History of St. Joseph's Parish
 and the Catholic Church in
 Macon, A 8
Brown, Katherine, Ph.D 8, 143
Burkhalter, Craig 8, 74, 75
Butler, John C. 13

C

Canterbury Cathedral 87
Cararra, Italy 27, 181
Carrara marble 25, 27, 30, 85, 147,
 162, 183

Cathedral of St. John the Baptist 40
Catholic cemetery 16
Chartres Cathedral 87
Christ with crown of thorns 99
Church of the Assumption 12
Clayton, Nicholas Joseph 14
Coleman, Craig 85
Coole, County Westmeath,
 Ireland 37
Corsini, Henry 24
Crosby, Sean 81, 82
Crown of Victory and Palms 91
Cruysgang (Way of the Cross) 144
Cuddy, Monsignor John 8, 34, 40, 61
Cupola 21, 33, 56, 80, 81, 179

D

DaVinci, Leonardo 25, 27, 172
Degering, J.G. 27, 61
Denis Cathedral 87
DeSoto, Hernando 11
Diocese of Savannah-Atlanta 34
Downs, Patty 40, 61, 70, 72
Durham, Willy 75

F

Firmin, Father Dan 70
Fourth Street School 13
Fulton Baptist Church 12

G

Galveston, Sacred Heart Church 14
Galveston, Texas 14
Georgia marble 16, 18, 30, 78
Giglio, Celia Weisz 16
Graham, Father James 11

H

Henigman, Celia 43, 52
Henigman, Jim 43, 51
High Altar 25, 27, 31, 33, 70, 165,
 166, 167, 172, 173, 174
History of Saint Joseph's
 Parish, Macon 8, 164
Holy Eucharist 7, 30, 95, 115, 165
Holy Spirit 56, 80, 91
Holy Trinity 164

I

Italian Gothic period 27

J

Jaekel, Wilfried 43
Jesuits 7, 14, 25, 34, 88, 103, 108,
 110, 114, 121, 125, 132, 133,
 134, 139, 162
Jesus 25, 27, 32, 88, 103, 108, 114,
 125, 132, 134, 143, 148-161,
 162, 164
John the Baptist 164

K

Kelly, Joseph B. 43
Keys to the Kingdom 115
King Hezekiah 87

L

Lamb of God 111
Last Supper 21, 172
Little Way 164
Long, Mr. A. T. 40, 61
Long, Tony 5, 8, 39, 40, 61, 62, 70,
 72
Lorsch Abbey 87

M

Macon City Directory 12
Macon News 15, 27, 61
Macon Power Inc. 56, 59
Macon Telegraph 16
Mary 27, 106, 109, 128, 144
Mary Magdalene 25, 101
Mayer, Franz 41, 88
Mayer, Joseph Gabriel 43
Mayer, Konrad 88
Mayer Studio 32, 43, 47, 88, 183
McDonald, Father Allan 7, 8, 34
Mount de Sales Academy 14
Munich, Germany 32, 43, 179

N

National Register of Historic
 Places 18
Nativity 131

O

O'Hara, Bishop Gerald P. 34
O'Neill, Monsignor William O. 40
Ocmulgee River 11
Olmsted, Katy 8, 74, 75, 85
Otten, S.J., Brother Cornelius
 14, 15, 147, 183
Our Lady of Lourdes 105
Our Lady of Sorrows 64, 98

P

Pilcher and Sons 32
Pio Nono College 14
Pope Benedict XIV 144
Pope Clement XII 144
Pope John Paul II 146
Pope Leo XIII 88

Pope Pius XII 34
Pope St. Celestine I 164
Presbyterian Church 11, 12
Punaro, Angelo 37

Q

Quinlan, S.J., Father John 14

R

Reconciliation Room 21
Rohn, Rolf 8, 25, 40, 41, 61, 70,
 72, 75, 85
Rohn, Renate 8, 25, 71, 81, 84, 85
Rohn Design Group 40, 41, 56, 72
Roman Catholic Church 146
Rose Hill Cemetery 16
Rose window 18, 24, 32, 50, 54, 56,
 57, 118, 179
Rosso di Levanto marble 27

S

Sacred Heart Chapel and Altar
 25, 30, 53, 81, 85, 165, 174
Schlicker Organ Company 24, 30
Second Vatican Council 7, 21, 164
Shannon, Dudley 85
Sheehan, Right Reverend Monsignor
 Thomas I. 34
Sheridan, Christopher 37, 38
Sheridan, Chris R. & Co. 24, 44, 179
Sheridan, Chris R. Jr. 5, 8, 34, 37, 39,
 40, 43, 56, 61, 179
Sheridan, Sister Mary 8, 164
Sheridan Punaro Company 37
Sheridan, Robert 37, 38
Simmons, Leon 81, 82
Sisters of Charity 162

Sisters of Mercy 13, 14
Snyder, Ray 8, 74, 75
Solomon, Charles 75, 76
Spiritual Exercises 162
St. Agnes 90
St. Aloysius Gonzaga 110
St. Alphonsus of Liguori 94
St. Ambrose 134
St. Andrew 125
St. Anne 25, 27, 106
St. Anthony of Padua 94, 162, 168
St. Augustine 119, 134
St. Bartholomew 123
St. Benedict 120
St. Bernadette 105
St. Bernard 87, 138
St. Bridget 90
St. Catherine of Alexandria 135
St. Cecelia 54, 124
St. Denis Cathedral 87
St. Dominic 108
St. Elizabeth of Hungary 114
St. Francis (Hieronymus)
 di Girolamo 139
St. Francis de Sales 122
St. Francis of Assisi 140
St. Francis Xavier 110, 181
St. Gabriel, Archangel 27, 164, 170,
 171, 175
St. Germanus 164
St. Gregory the Great 126
St. Ignatius of Loyola 133, 162, 169
St. James Major 104, 136
St. James Minor 137
St. John 25, 100, 104, 111, 125
St. John Berchmans 110
St. Joseph 25, 27, 128, 130, 166
St. Joseph's School 13, 14, 21
St. Luke 83, 111

191

St. Mark 82, 95
St. Matthew 95
St. Matthias 64, 123
St. Michael, Archangel 27, 164, 171
St. Monica 119
St. Patrick 94, 163, 164, 181
St. Paul 35, 134
St. Peter 104, 125, 134, 146
St. Peter Canisius 121
St. Peter Claver 114
St. Philip 123
St. Raphael 164
St. Rose of Lima 90
St. Simon 136
St. Stanislaus College 14, 16
St. Teresa of Avila 90
St. Thaddeus 137
St. Therese of Lisieux 162, 164, 168
St. Thomas 64, 123, 127
St. Ursula 141
St. Veronica 114, 146
St. Vincent de Paul 114, 162, 169
Stabat Mater Dolorosa 147
Stallings, Jim 81
Sterchx, Peter 144
Story of the Soul 162
Strasbourg Cathedral 87
Suger, Abbot 87
Sutton, David 8, 74, 75

T

Tindal, Dennis 41, 70
Transept 16, 21, 32, 58, 64, 80, 81
Turner, Drexel 15

U

U.S. Department of the Interior 18

W

Wagner, S. J., Bro. John 15
Walk through St. Joseph's
 Catholic Church 8
Way of Sorrows 143
Way of the Cross 143
Weisz, Professor J. G. 16, 17
Wey, William 144
Witt, Larry 70
Woodruff, David B. 14
Woolf, Joni 5, 11, 87, 162
Wright, Robert H. 8, 12

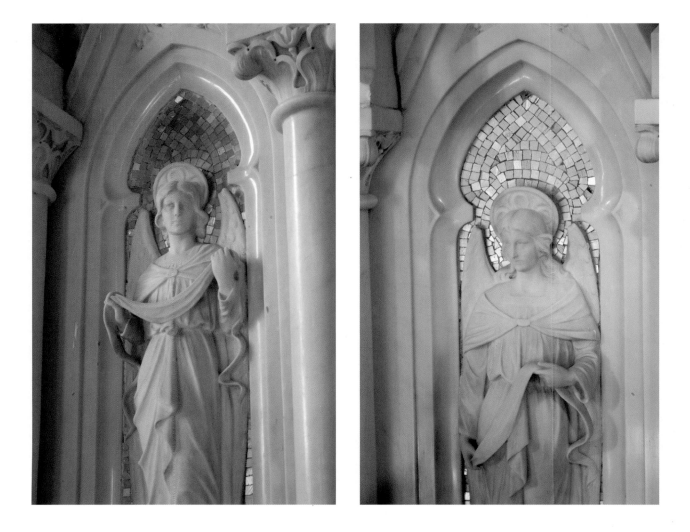

176

These angels appear at either side of the Blessed Mother Altar.

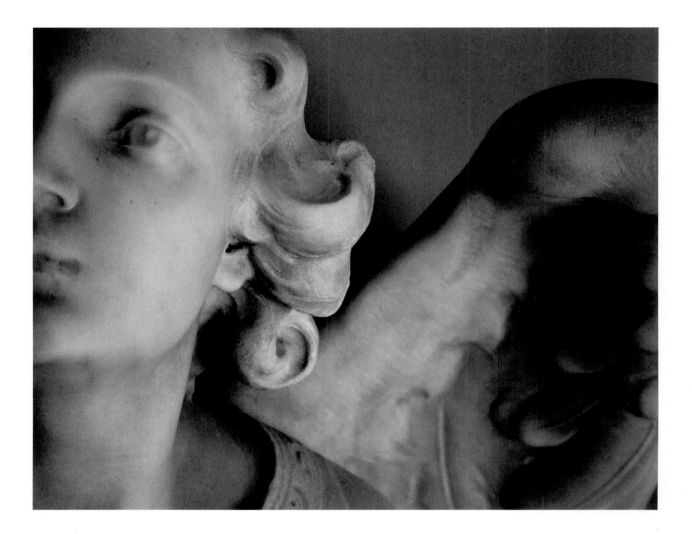

Detail of the Archangel St. Gabriel.